Design must embrace misunderstandings, mistakes and so-called misuse by people as a source of innovation and a means of improving cultural diversity. (from: First Declaration of the St. Moritz Design Summit)

Design muss Missverständnisse, Missbrauch und Fehler der Menschen als Quelle der Innovation und zur Verbesserung kultureller Vielfalt anerkennen (aus: Erste Deklaration des St. Moritz Design Summit)

El diseño debe reconocer en los malentendidos, los errores y el uso inapropiado por parte de la gente una fuente de innovación y un medio para mejorar la diversidad cultural (de la Primera Declaración de la St. Moritz Design Summit)

Le design doit s'inspirer des erreurs humaines de compréhension et d'utilisation pour innover et favoriser la diversité culturelle (extrait de la première déclaration du St. Moritz Design Summit)

Il design deve riconoscere gli equivoci, l'uso improprio e gli errori delle persone quali fonte d'innovazione e per il miglioramento della molteplicità culturale (tratto da: prima dichiarazione al Summit sul Design di St Moritz).

NON INTENTIONAL DESIGN

BY UTA BRANDES & MICHAEL ERLHOFF

daab

NID – DAY-TO-DAY REDESIGNING THE DESIGNED

Non Intentional Design (NID) is a term we have invented and which has not yet entered everyday linguistic use. (Perhaps this will change following publication of this book.) NID refers to the day-to-day redefining of the defined. NID deals with norms which are "abnormally" transformed – every day, everywhere, by everyone. It is about the use and the exploitation of objects already designed: the chair (also) becomes a coat stand, a surface to put things on, a ladder or – for example by piling books on the seat – a child's chair; staples are suitable for cleaning fingernails and for removing CDs from the computer; magnets on the fridge turn it into a notice board; steps are not just there to overcome differences in height, but also serve as seats and ramps for skaters; jam jars accommodate pens and Biros; cardboard boxes metamorphose into storage containers, a dirt track provides a shortcut... – the possibilities are endless. Look at your own living room, kitchen or desk from this perspective: you are no exception – you are also an NID person just like the rest of us.

Non Intentional Design lends apparently unambiguous objects a polymorphism, implies transformation combined with clever invention and novel functions. NID is created out of necessity, convenience and play. It is frequently reversible and sometimes the product will be given a definite new application. NID does not want to design anything; no new design is being created here. It simply uses, converts, and generates something new or replaces something old as a result. NID could spare us much expense and trouble and could open design professionals' eyes to a more sensitive perception of their clients' requirements.

The cultural diversity of the otherwise mainly globally organized and available world of products proves itself in usage only. It is high time to recognize the purely everyday, though exciting reinvention of all objects: because NID re-empowers people by returning to them their confidence and autonomous use of the object world.

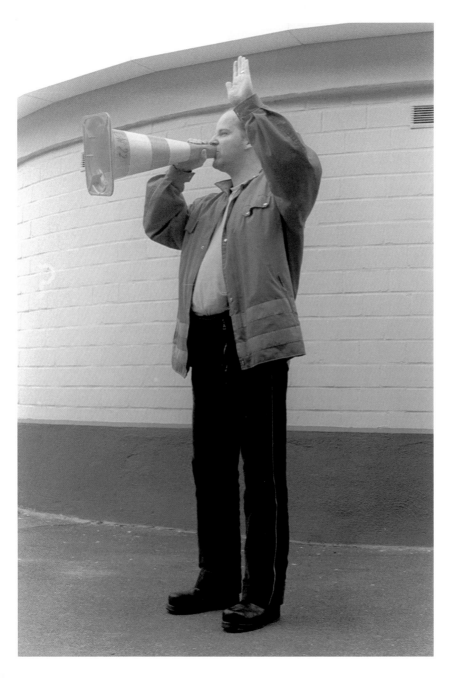

NID – DIE ALLTÄGLICHE UMGESTALTUNG DES GESTALTETEN

Non Intentional Design (NID) ist ein Begriff, den wir erfunden haben und der noch nicht in den allgemeinen Sprachgebrauch eingegangen ist. (Vielleicht ändert sich das ja nach der Veröffentlichung dieses Buches.) NID bezeichnet die alltägliche Umgestaltung des Gestalteten. NID handelt von Normen, die „ab-norm" umgewandelt werden – täglich, überall, von allen. Es geht dabei um den Gebrauch, um die Nutzung von bereits Gestaltetem: Der Stuhl wird (auch) zur Garderobe, zur Ablagefläche, Leiter oder – zum Beispiel durch auf der Sitzfläche gestapelte Bücher – zum Kinderstuhl; die Büroklammer eignet sich zum Reinigen der Fingernägel ebenso wie zur Entnahme von CDs aus dem Computer; der Kühlschrank wird mittels Magneten zugleich als Pinnwand genutzt; Treppen sind nicht nur zur Überwindung von Höhenunterschieden da, sondern dienen zugleich als Sitzbänke und Rampe für Skater; Marmeladen- und Senfgläser beherbergen Stifte und Kugelschreiber; Kartons wandeln sich zu Lagerregalen, der Trampelpfad kürzt den Weg ab... – die Beispiele lassen sich zahllos fortsetzen. Überprüfen Sie selbst unter dieser Perspektive Ihr Wohnzimmer, Ihre Küche oder Ihren Schreibtisch: Sie werden keine Ausnahme sein – auch Sie sind ein NID-Typ, wie wir alle.

Non Intentional Design gibt den scheinbar eindeutigen Dingen eine Vielgestaltigkeit, impliziert Transformation, kombiniert mit kluger Erfindung neuer Funktionen. NID entsteht aus Mangelsituationen, aus Bequemlichkeit, aus Spieltrieb. Es ist häufig reversibel, manchmal wird das Produkt aber auch einem endgültig neuen Zweck zugeführt. NID will nicht gestalten, hier wird kein neues Design geschaffen. Es gebraucht nur, es nutzt um, erzeugt dabei Neues oder ersetzt Altes. NID könnte uns viel Kosten und viel Ärger ersparen und den Designprofis die Augen für eine sensiblere Wahrnehmung der Wünsche ihrer Kundschaft öffnen.

Im Gebrauch erweist sich nämlich die kulturelle Vielfalt der ansonsten meist global organisierten und verfügbaren Produktwelt. Es wird höchste Zeit, die ganz alltäglichen und doch so spannenden Neuerfindungen der Objekte in aller Welt zur Kenntnis zu nehmen: Denn NID gibt den Menschen ihre selbstbewusste und autonome Verfügung über die Gegenstandswelt zurück.

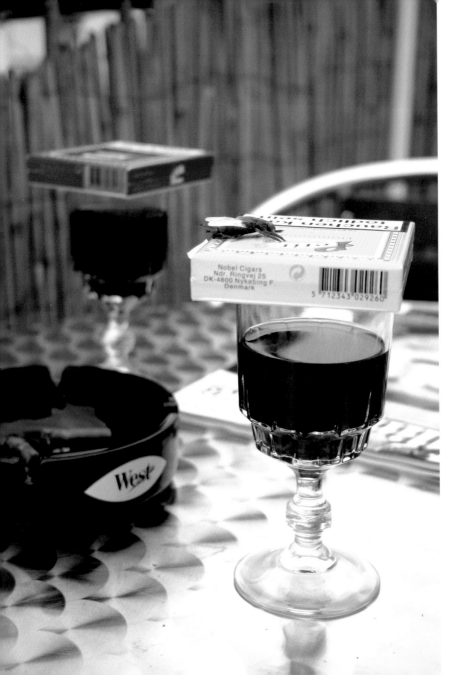

NID – EL REDISEÑO COTIDIANO DE LO DISEÑADO

Non Intencional Design (Diseño No Intencionado, NID en su acrónimo inglés) es un concepto que hemos inventado nosotros y que todavía no forma parte del uso idiomático general. (Tal vez cambien las cosas tras la publicación de este libro). NID define el rediseño cotidiano de lo diseñado. NID trata de normas, que son transformadas de manera ab-norma diariamente, en todas partes y por todos. Se trata del uso, de la utilización de lo ya diseñado: la silla que se convierte (también) en guardarropa, aparador, escalerilla o, por ejemplo a base de apilar libros sobre el asiento en trona infantil; el clip sirve lo mismo para limpiarse las uñas que para extraer los CD del ordenador; el frigorífico que mediante el uso de imanes se convierte en tablón de anuncios; escaleras que no sólo sirven para salvar alturas, sino también como bancos para sentarse y rampas para los monopatines; frascos de mermelada o mostaza que guardan lapiceros y bolígrafos; cajas de cartón que se convierten en estanterías, el camino trillado que ataja el trayecto...los ejemplos se repiten infinitamente. Examine usted mismo bajo esta perspectiva su cuarto de estar, su cocina o su escritorio: no va a ser una excepción: también usted es un tipo-NID, como todos nosotros.

Non Intencional Design proporciona a las cosas aparentemente claras una multifuncionalidad, implica transformación combinada con la inteligente invención de nuevas funciones. NID surge en situaciones de carencia, por comodidad o ganas de jugar. A menudo es reversible, pero a veces el producto se destina definitivamente a una nueva finalidad. NID no quiere diseñar, no pretende crear aquí ningún nuevo diseño. Sólo utiliza, emplea, produciendo así algo nuevo o sustituyendo algo viejo. NID podría ahorrarnos mucho dinero y problemas, y permitiría a los profesionales del diseño abrir los ojos para percibir de un modo más sensible los deseos de sus clientes.

El modo de empleo se convierte en la propia diversidad cultural del mundo de los productos, por lo general globalmente organizados y disponibles. Ha llegado el momento de que en todo el mundo se tenga conocimiento de las reinvenciones de objetos completamente cotidianas y a la vez tan interesantes: y es que el NID devuelve a las personas su capacidad para disponer de forma consciente y autónoma sobre el mundo de los objetos.

NID – OU LE DÉTOURNEMENT AU QUOTIDIEN DES OBJETS USUELS

Non Intentional Design (NID) est un terme que nous avons inventé et que la langue parlée n'a pas encore adopté. (Peut-être cela changera-t-il après la publication du présent ouvrage.) Le NID, cela signifie détourner au quotidien des objets usuels. Le NID, ce sont des normes transformées de façon «a-normale» – tous les jours, partout et par tous. Il s'agit de l'emploi, de l'utilisation d'objets existants: la chaise devient (aussi) vestiaire ou surface de rangement, escabeau ou encore, pour peu que l'on y empile des livres, chaise haute pour enfant; le trombone sert à nettoyer les ongles aussi bien qu'à extraire les CD de l'ordinateur; il suffit de quelques aimants pour métamorphoser le réfrigérateur en tableau d'affichage; les marches, certes, permettent toujours de franchir des écarts de niveau, mais aussi de s'asseoir ou, aux skaters, de s'exercer; crayons et stylos à bille prennent place dans les pots de confiture et de moutarde; les cartons se transforment en étagères, le raccourci devient le chemin officiel… – la liste des exemples n'en finit pas. Vérifiez vous-même, dans cette optique, votre salon, votre cuisine ou votre bureau: vous n'y échappez pas: vous êtes également un adepte du NID, comme nous tous.

Le Non Intentional Design multiplie les usages possibles d'objets n'ayant apparemment qu'une vocation, implique des transformations, combine de nouvelles fonctions avec des inventions pleines d'astuce. Le NID doit son existence à un manque, à la facilité, à une impulsion ludique. Souvent réversible, il peut aussi conférer au produit une nouvelle fonction définitive. Le NID ne veut pas façonner, ni créer un nouveau design. Il ne fait qu'utiliser, détourne un emploi, et, de ce fait, fabrique du neuf ou remplace de l'ancien. Le NID pourrait nous épargner bien des dépenses et des agacements, tout en rendant les professionnels du design plus sensibles aux souhaits de leur clientèle.

En effet, la diversité culturelle du monde des produits disponibles et organisés le plus souvent à l'échelle mondiale, se manifeste dans leur emploi. Il est grand temps de prendre connaissance, dans le monde entier, des nouveaux usages, banals et pourtant si intéressants, inventés pour les objets: car le NID rend aux humains leur pouvoir de disposer du monde des objets selon leur volonté et en toute autonomie.

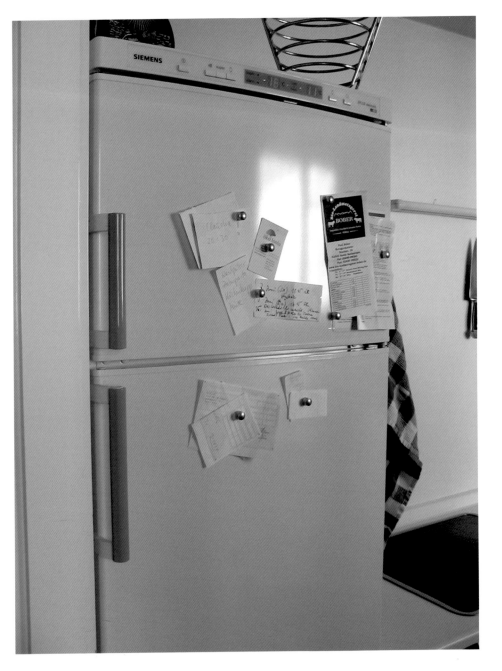

NID – LA TRASFORMAZIONE QUOTIDIANA DEL DISEGNO

Non Intentional Design (NID) è un concetto da noi inventato e non ancora entrato nel linguaggio comune (forse lo farà dopo la pubblicazione di questo libro). La denominazione NID indica la trasformazione quotidiana dell'esistente: il NID si occupa di norme che vengono trasformate ab-norma: quotidianamente, ovunque e per qualsiasi cosa. Si tratta dell'impiego, dell'utilizzo di oggetti già esistenti: la sedia si trasforma (anche) in guardaroba, in una superficie portaoggetti, in una scala o – ad esempio con dei libri impilati sulla seduta – in una sedia per bambini; i fermagli ben si prestano per la pulizia delle unghie così come per estrarre i CD dal computer; grazie ai magneti, il frigorifero si trasforma in una bacheca; le scale non esistono solo per superare dislivelli, ma allo stesso tempo sono anche panchine e rampe per lo skateboard; i vasetti di marmellata e di senape ospitano matite e penne; le scatole di cartone si trasformano in mensole, il sentiero battuto accorcia la strada... Gli esempi si potrebbero protrarre all'infinito: provate voi stessi a guardare il vostro salotto, la cucina o la vostra scrivania in base a questa prospettiva; non sarete certo un'eccezione: anche voi siete un „tipo NID", come noi tutti.

Il Non Intentional Design conferisce alle cose apparentemente univoche un'essenza multiforme, implica una trasformazione, abbina nuove funzioni grazie ad argute invenzioni. Il NID nasce da situazioni di carenza, dal desiderio di comodità, dalla voglia di giocare; spesso è reversibile, a volte viene conferito al prodotto anche uno scopo nuovo, definitivo. Il NID non vuole creare forme nuove, e neanche un nuovo design; viene solo utilizzato, è utile, produce il nuovo o sostituisce il vecchio. Il NID potrebbe farci risparmiare soldi e arrabbiature facendo aprire gli occhi ai professionisti del design e offrendo loro una percezione più sensibile dei desideri della loro clientela.

Nell'utilizzo si rivela infatti la molteplicità culturale del mondo dei prodotti, altrimenti globalmente organizzato e sempre disponibile. Sarebbe proprio ora di prendere atto di tutte le nuove invenzioni in tutto il mondo di oggetti comuni, ma allo stesso tempo così avvincenti: allora il NID restituirebbe alle persone la possibilità di disporre, consapevolmente e autonomamente, del mondo degli oggetti.

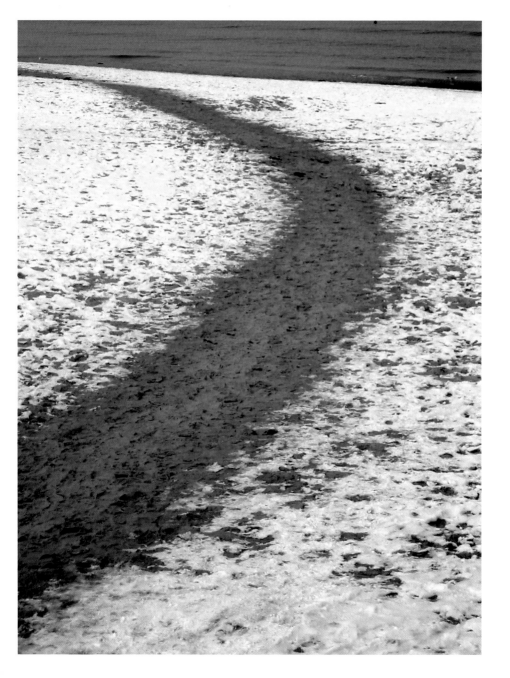

Subversive: to generate new methods, known as pathways, by means of quicker or cleverer, perhaps more attractive shortcuts.

Subversiv: durch schnellere oder klügere, vielleicht auch schönere Abkürzungen neue Wege, genannt Trampelpfade, gestalten

Subversivo: mediante atajos más rápidos o inteligentes, quizá también más bonitos, se crean nuevos senderos, los llamados caminos trillados.

Subversif: tracer de nouveaux chemins, raccourcis plus rapides ou plus astucieux, peut-être aussi plus beaux.

Sovversivo: grazie a scorciatoie più veloci o più argute, forse anche più belle, vengono creati nuovi percorsi, detti sentieri battuti.

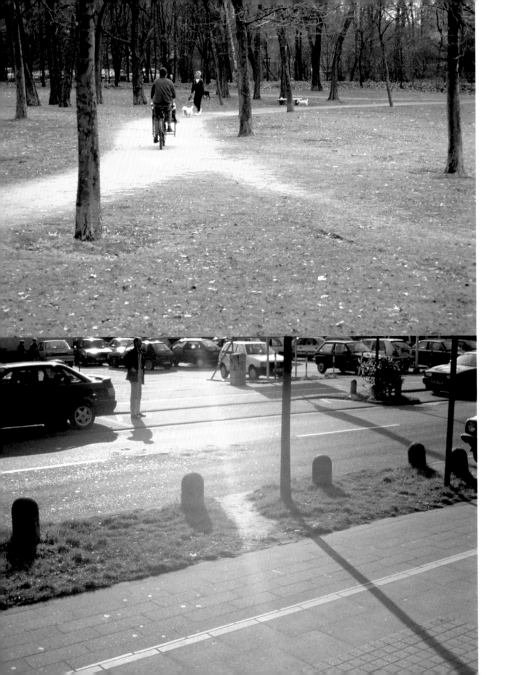

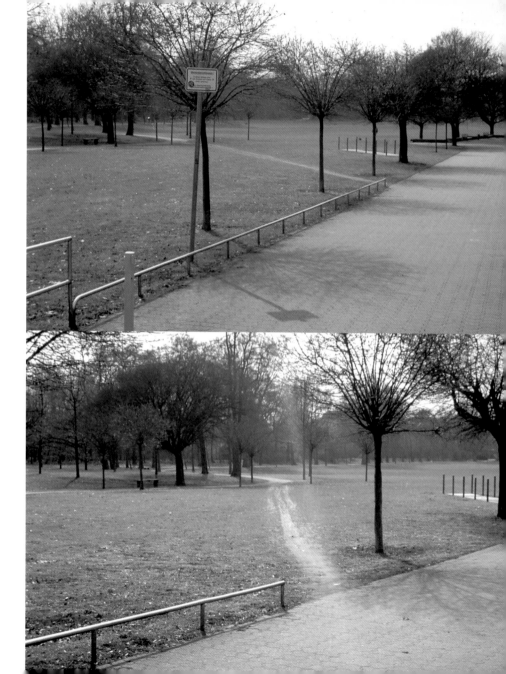

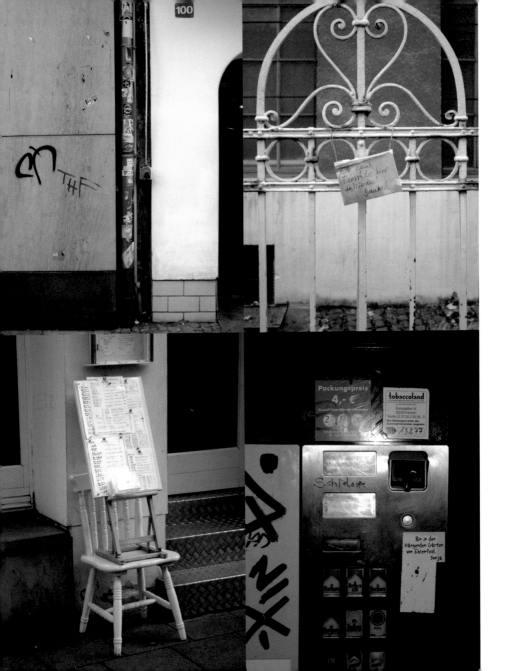

Children are world champions at changing the function of all conceivable objects for their own joy and play; though they only ever do this to satisfy the moment, not the future.

Kinder sind Weltmeister darin, alle erdenklichen Gegenstände für die eigene Lust und das Spiel umzufunktionieren; aber stets nur für die unmittelbare situative Befriedigung, nicht vorausschauend.

Los niños son auténticos maestros a la hora de transformar cualquier objeto imaginable para el juego y su propio placer; pero siempre de cara a satisfacer las necesidades de la situación inmediata y sin previsión alguna.

Les enfants sont des champions pour transformer tous les objets imaginables afin de satisfaire leur plaisir et leur envie de jouer; mais toujours pour leur seule satisfaction immédiate, et sans vision d'avenir.

I bambini sono campioni nell'adattare tutti gli oggetti a proprio piacimento e per il gioco, ma sempre e solo per un appagamento immediato e situativo, non con lungimiranza.

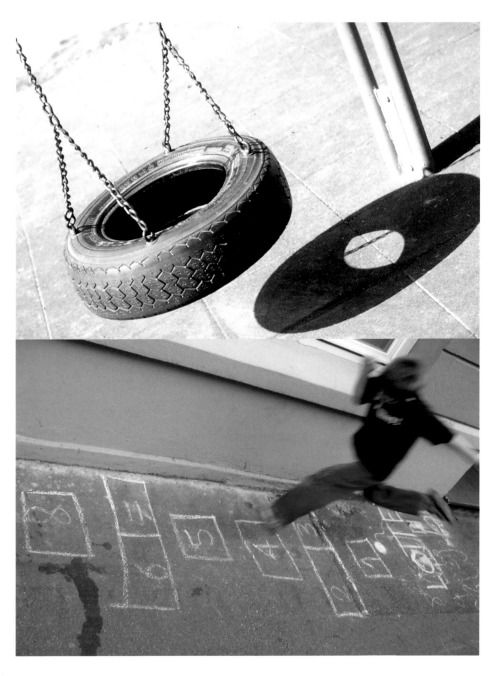

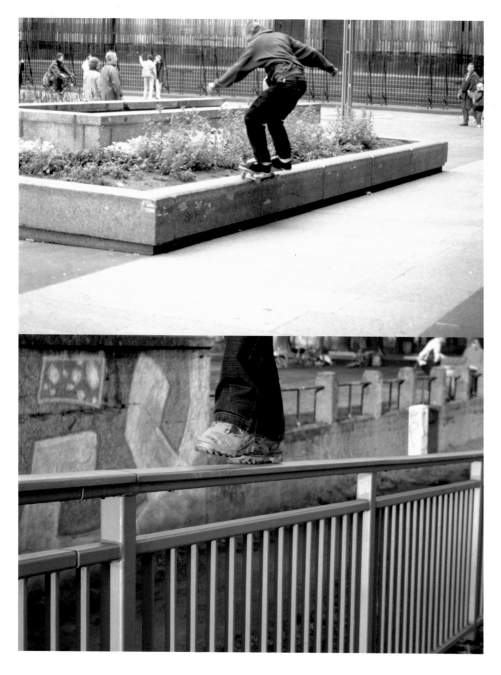

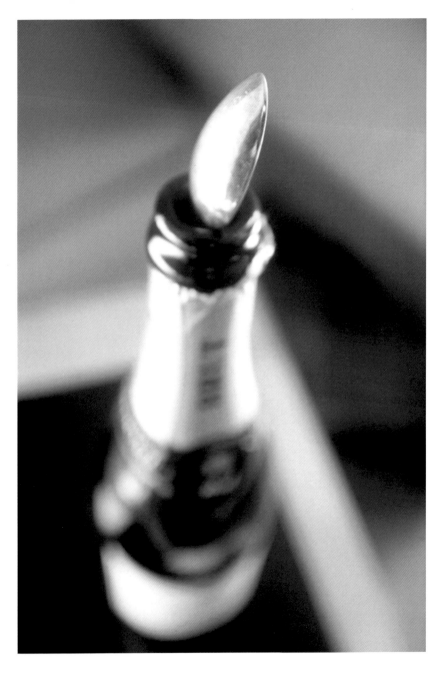

A metal teaspoon prevents sparkling white wine or champagne going flat overnight.

So verhindert ein metallener Teelöffel, dass der Sekt oder Champagner über Nacht schal wird.

Una cucharilla metálica evita de este modo que el champaña pierda fuerza durante la noche.

Une cuiller à café empêche le mousseux ou le champagne de s'éventer.

In questo modo un cucchiaino di metalloimpedisce che lo spumante o lo champagne si sfiati durante la notte.

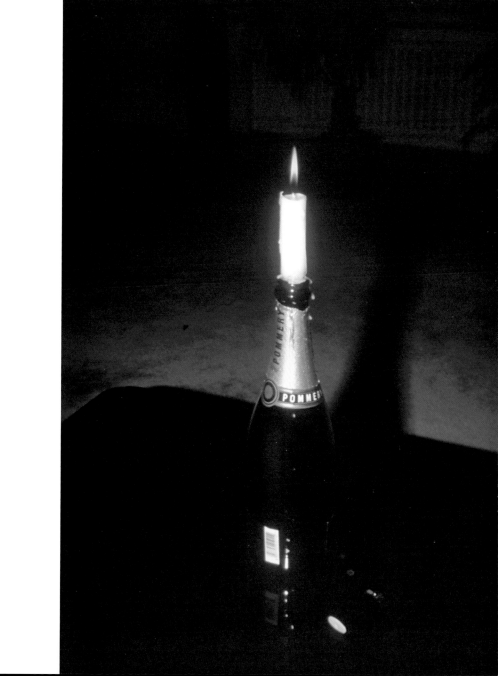

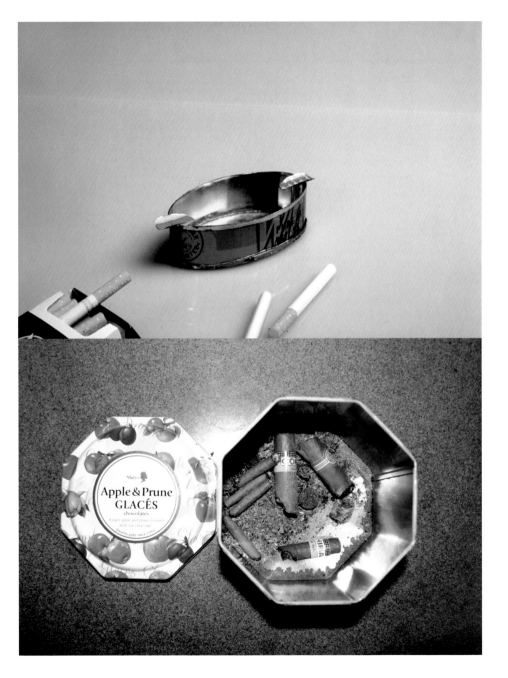

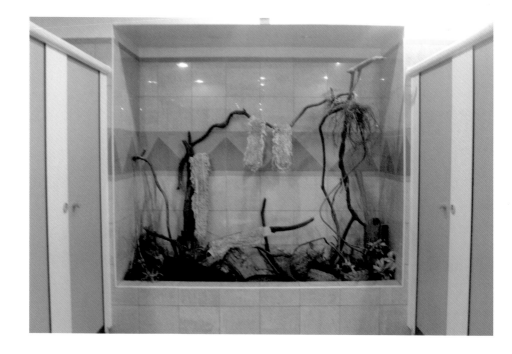

In order to brighten the quite depressing appearance of the ladies' toilets in Kuala Lumpur/ Malaysia airport a kind of herbarium with plants was installed. The cleaning ladies have taken to using the distinctive branches to dry their cloths and mops, thus lending the whole scene a rather beautiful though bizarre touch.

Um die in ihrer Anmutung recht deprimierenden Damentoiletten im Flughafen von Kuala Lumpur/Malaysia etwas aufzuheitern, wurde eine Art Herbarium mit Pflanzen angelegt. Die aparten Äste werden mittlerweile aber von den Putzfrauen zum Trocknen ihrer Wischtücher und Mopps benutzt, was dem Ganzen einen schön-bizarren Anstrich verleiht.

Remember: application always implies action, being productive: reading, handling things, living or loving. But storing things and listening and viewing are also acts that do not simply happen to us, are not situational descriptions, but constitute actions, too. There truly is a permanently productive reception and each perception and experience reconstruct the perceived and the experienced. Acquirement always takes place actively – the acquired object and that with which we are dealing being altered as a result. It is precisely this which provides proof of the human powers of imagination and design.

Merke: Gebrauchen ist immer Aktion, produktive Tätigkeit: Lesen, Hantieren, Wohnen, Lieben, aber auch Aufbewahren und selbst Zuhören und Anschauen widerfahren einem nicht und sind deshalb keine Zustandsbeschreibungen, sondern Handlungen. Tatsächlich gibt es permanent eine produktive Rezeption und bilden jede Wahrnehmung und Erfahrung das Wahrgenommene und Erfahrene um. Die Aneignung geschieht immer aktiv und verändert dabei den angeeigneten Gegenstand und das, womit man umgeht. Gerade darin erweisen sich menschliche Einbildungs- und Gestaltungskompetenz.

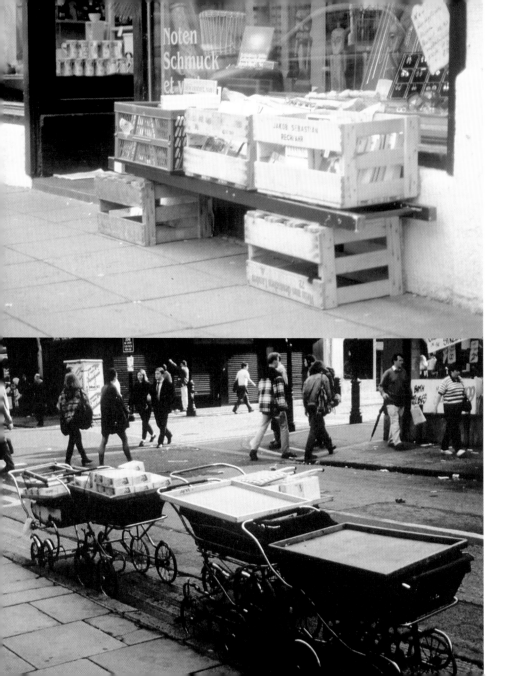

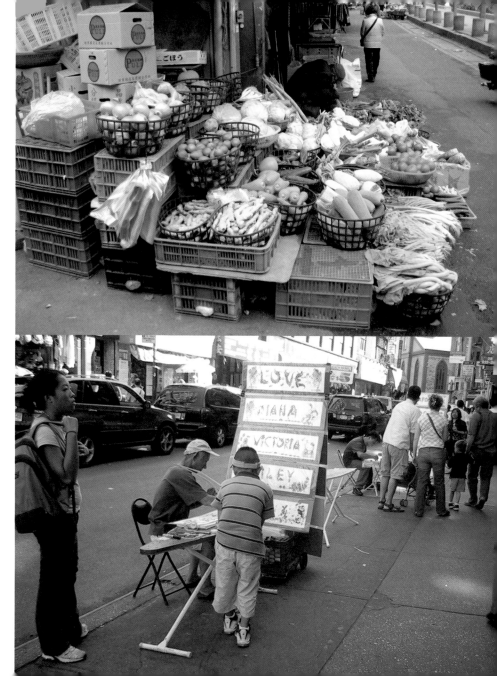

Nota: el hecho de utilizar es siempre acción, actividad productiva; leer, trabajar, vivir, amar, no son cosas que le sucedan a uno, pero tampoco guardar y ni siquiera escuchar ni mirar y por eso no describen estados sino acciones. De hecho hay permanentemente una recepción productiva, y toda percepción y experiencia transforman lo percibido y experimentado. La apropiación sucede siempre de modo activo y de este modo, transforma el objeto del que nos apropiamos y aquello que manejamos. Ahí precisamente se demuestra la capacidad humana para imaginar y diseñar.

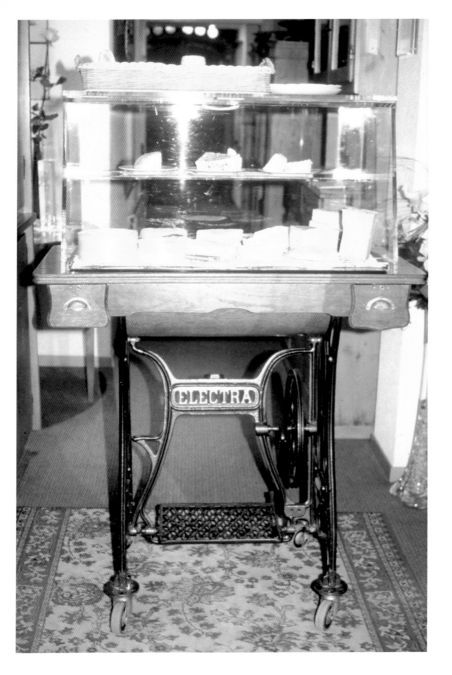

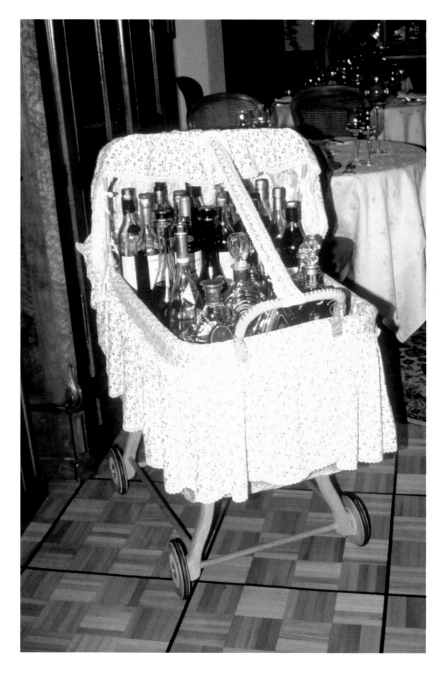

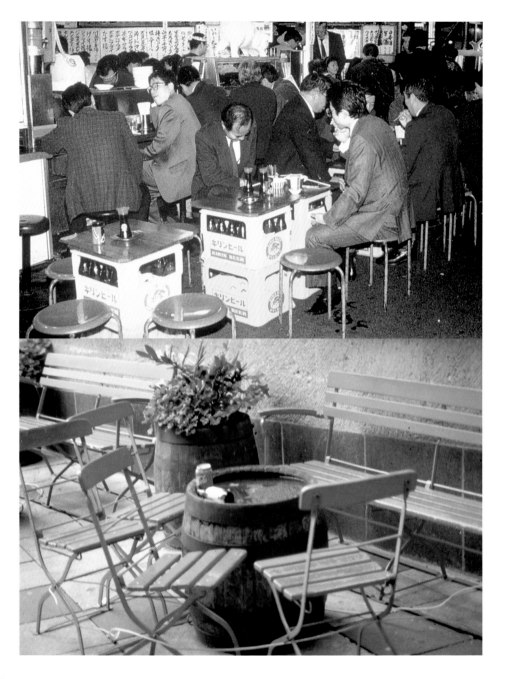

The chair, one of the most frequently designed and redesigned objects: inventing diverse new functions through usage.

Der Stuhl, einer der am häufigsten gestalteten und auch umgestalteten Gegenstände: im Gebrauch vielfältige neue Funktionen erfinden

La silla, uno de los objetos creados y recreados con más frecuencia: con el uso se inventan numerosas funciones nuevas

La chaise, l'un des objets les plus courants mais aussi les plus transformés: à l'usage, lui découvrir plusieurs fonctions nouvelles

La sedia, uno degli oggetti più spesso realizzati, ma anche rivoluzionati: con l'uso si possono inventare nuove e svariate funzioni.

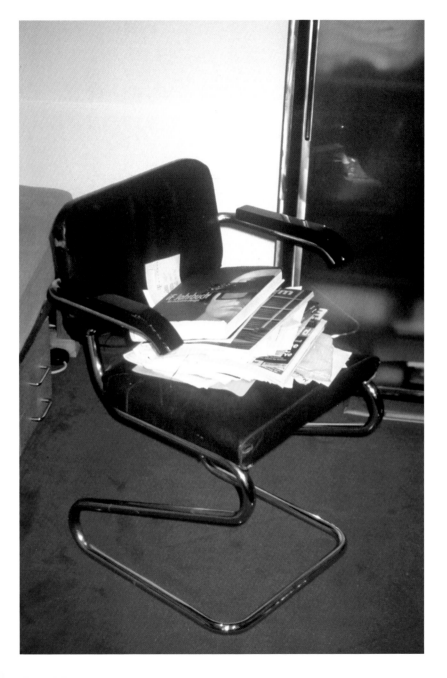

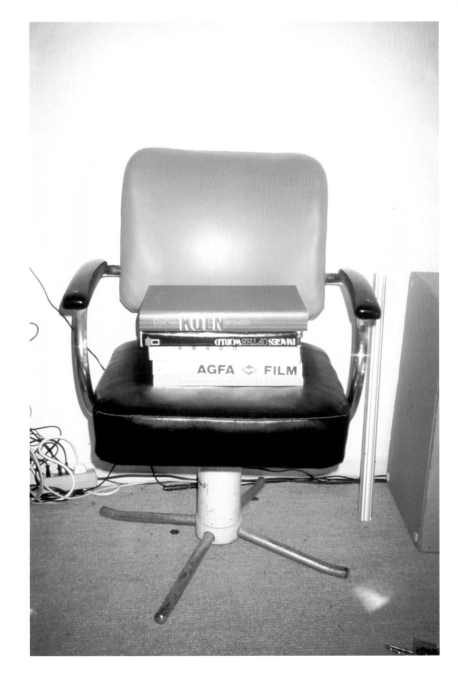

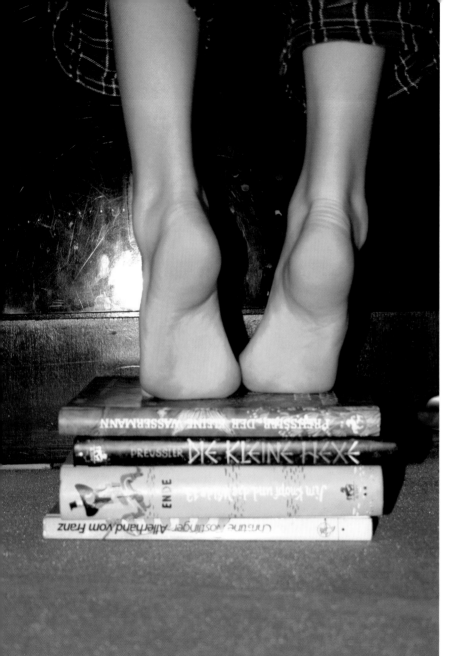

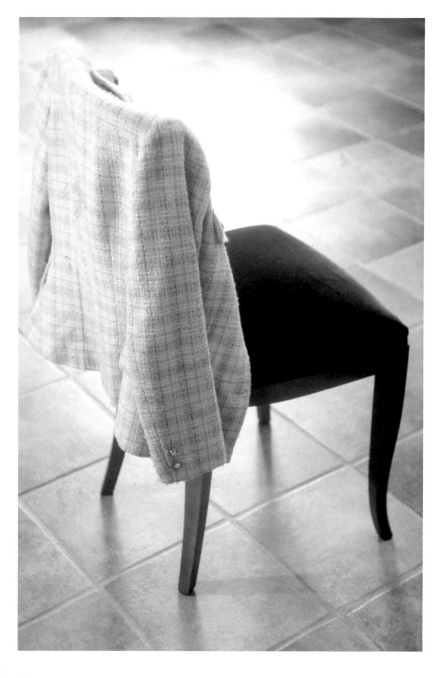

Note: l'utilisation est toujours une action, une activité productive; lire, bricoler, habiter, aimer mais aussi conserver et même écouter ou regarder n'agissent pas sur la personne et ne correspondent donc pas à des états, mais à des actions. En effet, nous sommes toujours réceptifs dans un sens productif, et transformons chaque perception et expérience en choses perçue et expérimentée. L'appropriation se déroule toujours de façon active et modifie de ce fait l'objet approprié et la chose manipulée. C'est justement en cela que l'homme prouve sa compétence en matière d'imagination et de création.

Ricorda: L'utilizzo è sempre azione, attività produttiva: leggere, utilizzare, abitare, amare, ma anche conservare e perfino ascoltare e guardare non accadono ad una persona e non sono quindi descrizioni di stati, bensì azioni. Infatti, vi è permanentemente una ricezione produttiva ed ogni percezione ed esperienza ricrea ciò che si è percepito e sperimentato. L'acquisizione accade sempre attivamente e modifica, allo stesso tempo, l'oggetto acquisito e ciò che una persona maneggia. Proprio qui si rivelano le competenze umane progettuali ed immaginative.

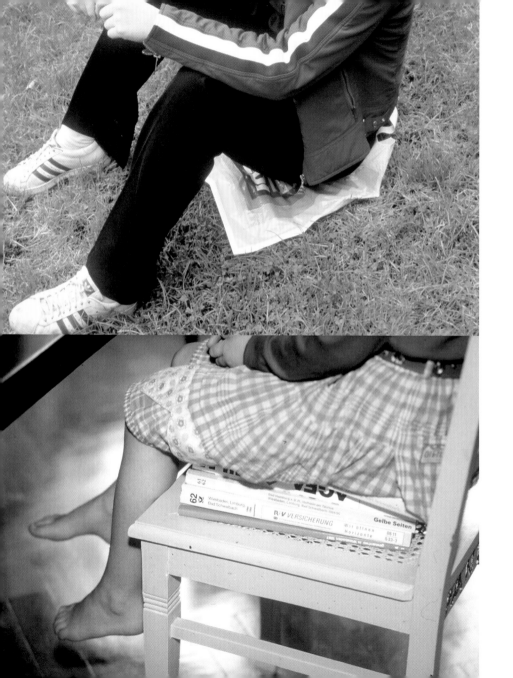

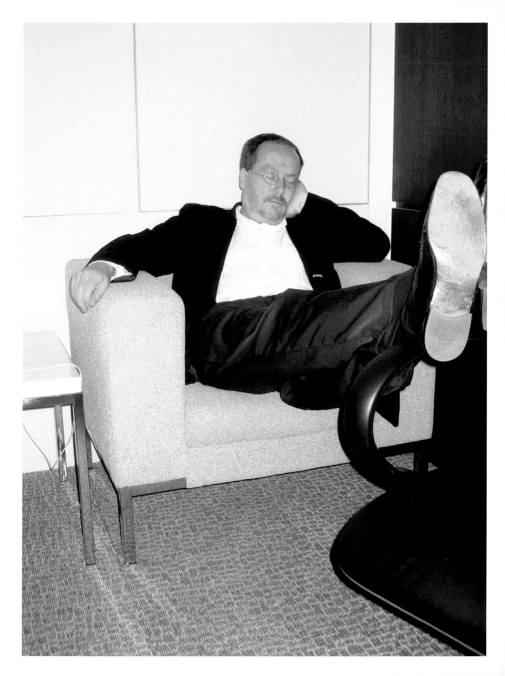

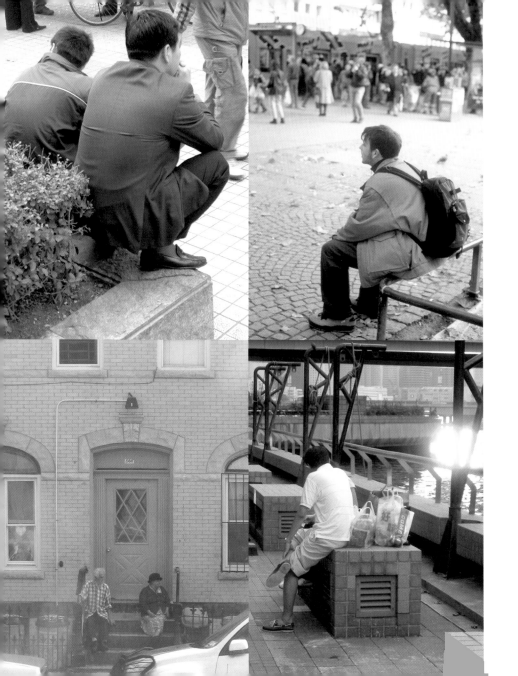

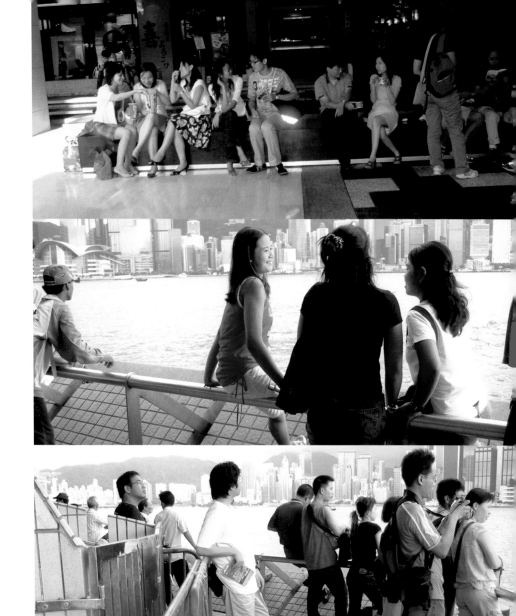

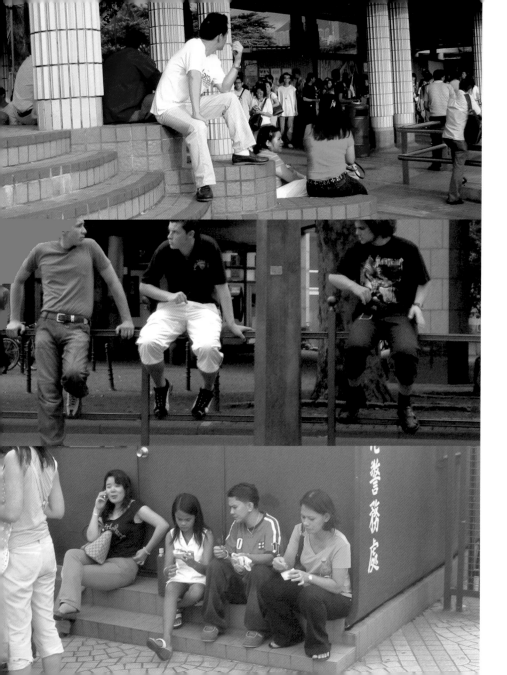

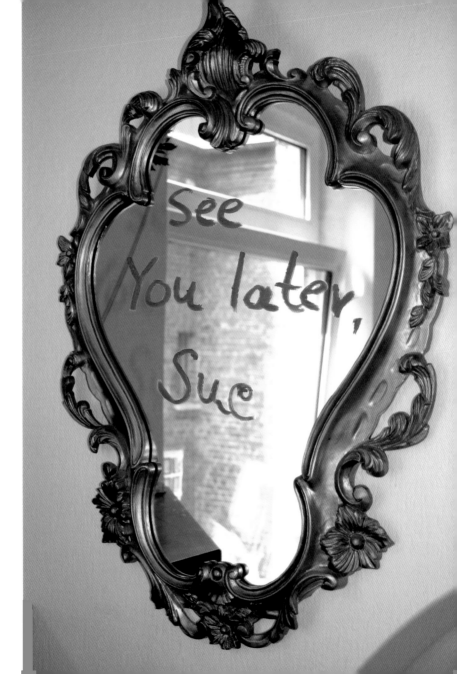

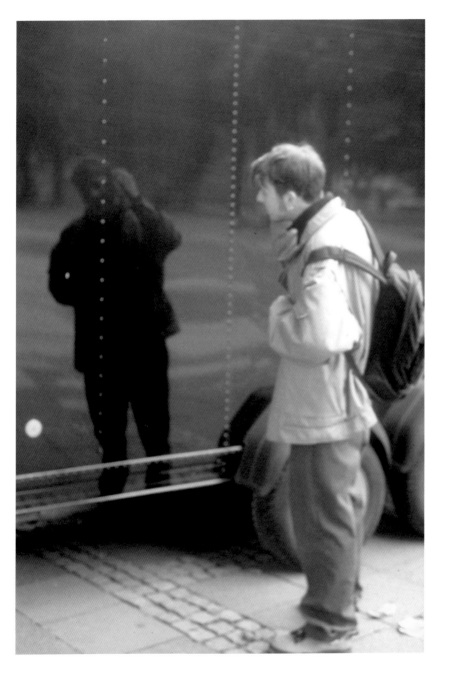

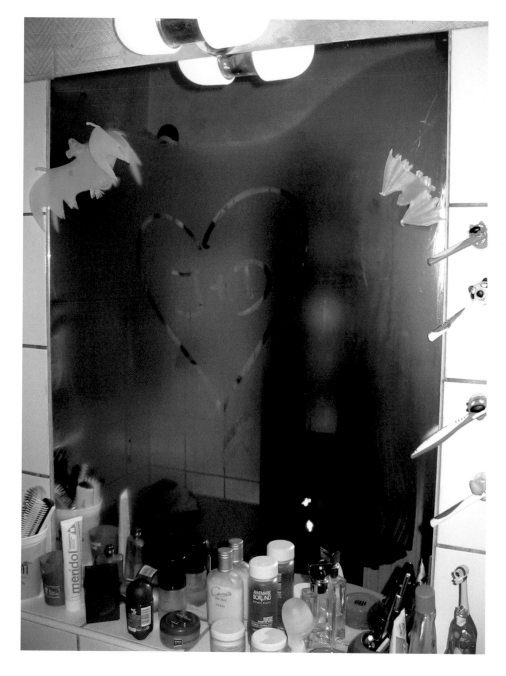

Storing and organizing count among the most pressing problems of human existence and demand creative solutions.

Aufbewahren und Ordnen gehören zu den eindringlichsten Problemen menschlichen Daseins, und sie verlangen nach kreativen Lösungen.

Guardar y ordenar forma parte de los problemas más acuciantes de la existencia humana y requiere soluciones creativas.

Conserver et ranger comptent parmi les problèmes les plus cruciaux de l'existence humaine et requièrent des solutions novatrices.

La conservazione degli oggetti e il far ordine appartengono ai problemi più ricorrenti della vita umana e richiedono soluzioni creative.

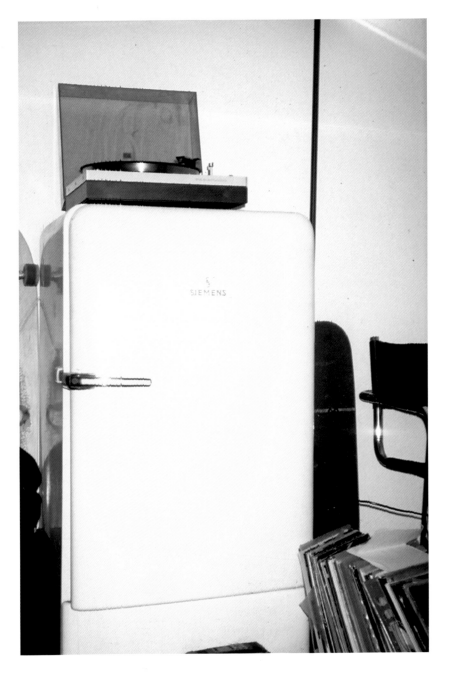

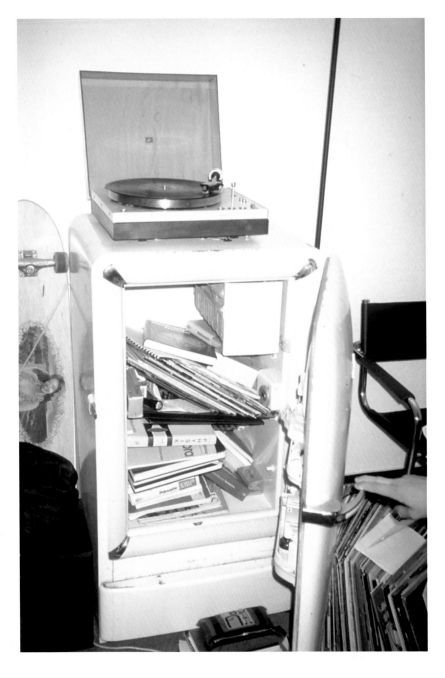

Take nothing for granted but perceive the possibility for change in everything!

Nichts als gegeben hinnehmen, sondern alles als veränderbar begreifen!

¡No hay que aceptar nada como definitivo, todo es susceptible de cambio!

Ne pas accepter d'état figé, mais voir en toute chose un objet évolutif!

Non accettate niente come dato, ma considerate tutto quello che afferrate come modificabile.

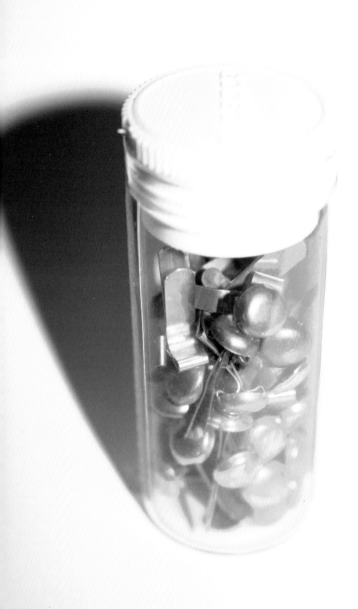

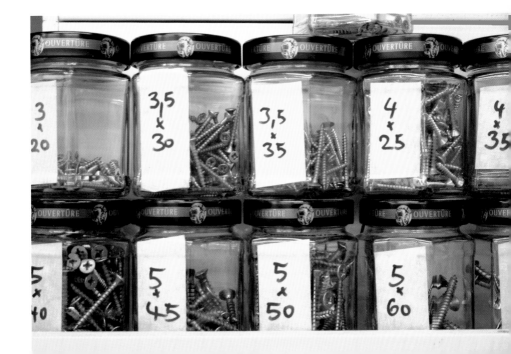

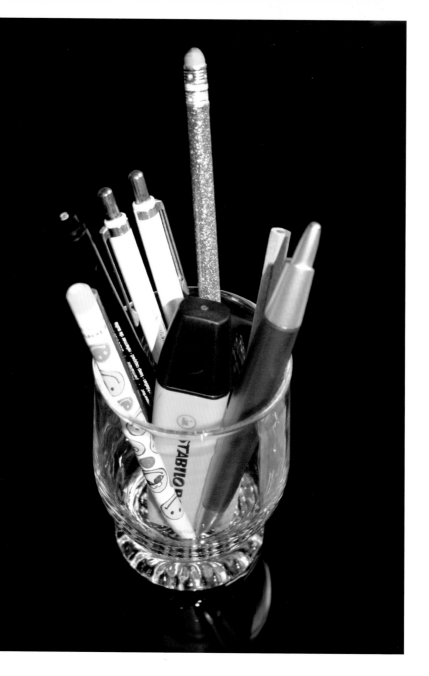

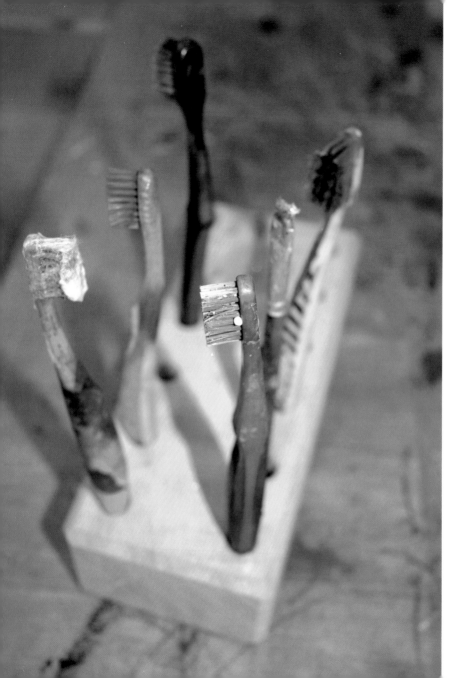

Fishing boats (here in Sai Kung / Hong Kong) as cheap and attractive point of sale. On closer inspection, however, there is more than meets the eye at first glance: long poles are used to pass the goods in nets up to the customers standing above on the quay; payment is conducted in exactly the same way – only the other way round.

Fischerboote (hier in Sai-Kung / HongKong) als preisgünstiger und attraktiver Point of Sale. Bei genauerem Hinsehen passiert aber noch mehr: Die Ware wird den oben am Kai stehenden Kunden in Käschern an langen Stangen von unten nach oben gereicht; die Bezahlung erfolgt genauso – nur von oben nach unten.

Barcas de pescadores (aquí en Sai-Kung / HongKong) como punto de venta económico y atractivo. Al observar atentamente se aprecian más cosas: buitrones con largas varas hacen llegar las mercancías de abajo a arriba a los clientes que se encuentran en lo alto del muelle; el pago se efectúa del mismo modo, sólo que ahora se hace de arriba a abajo.

Les bateaux de pêche (ici à Sai-Kung / Hong-Kong) se transforment en points de vente pittoresques et d'un coût minime. À y regarder de plus près, on distingue autre chose encore: sur le quai, le client reçoit sa marchandise dans un filet accroché à une longue perche, soit de bas en haut; le paiement s'effectue par la même voie, mais de haut en bas.

Le barche da pesca (nella foto a Sai-Kung / Hong Kong) vengono utilizzate come punti vendita economici e attraenti. Ad un esame più attento, si notano ben più cose: la merce viene offerta, dal basso verso l'alto, ai clienti che si trovano sulla banchina, in retini posizionati su lunghi pali; il pagamento avviene allo stesso modo: dall'alto verso il basso, però.

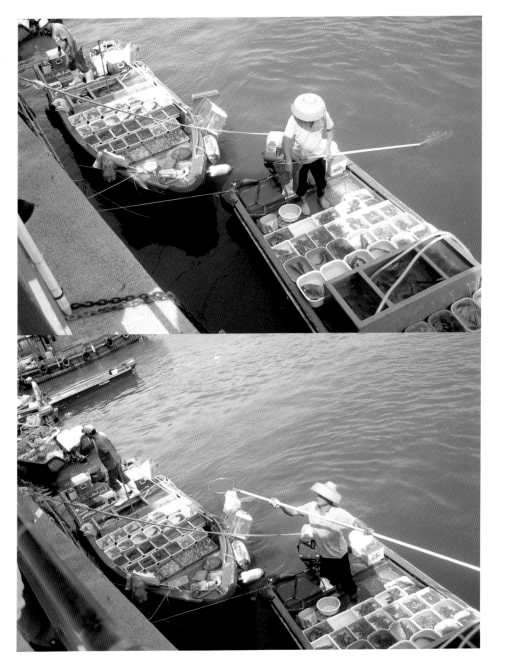

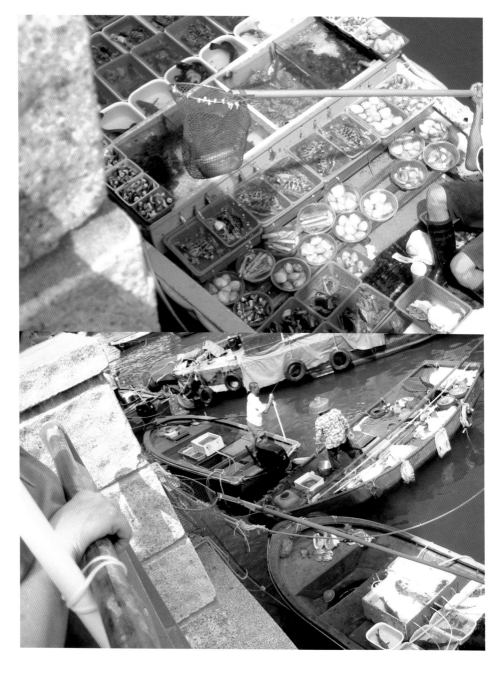

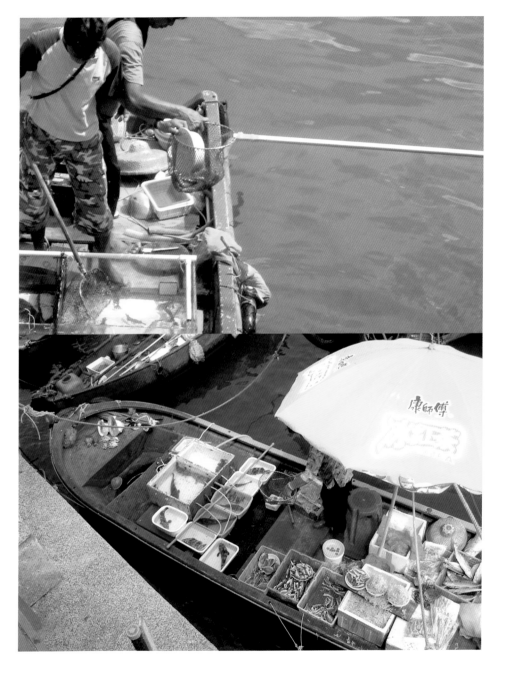

People are becoming increasingly mobile with the result that they are constantly transporting things back and forth: bringing home groceries from the supermarket; taking children, bags, books to school or to work, tools to the building site... For all this we invent innumerable containers which originally served other purposes.

Menschen werden zunehmend mobiler, und das bedeutet auch: Sie transportieren permanent große und kleine Dinge hin und her: Lebensmittel aus dem Supermarkt nach Hause, Kinder, Taschen, Bücher zur Schule oder zur Arbeit, Werkzeug zur Baustelle... Dafür nutzen und erfinden sie zahlreiche Behälter, die ursprünglich anderen Zwecken dienten.

Las personas cada vez tienen más movilidad, lo que significa que transportan continuamente de aquí para allá grandes y pequeñas cosas: alimentos del supermercado a casa, niños, bolsas, libros a la escuela o el trabajo, herramientas a la obra... para ello utilizan e inventan numerosos recipientes que originalmente servían para otros fines.

Les hommes sont de plus en plus mobiles, ce qui signifie par ailleurs qu'ils ne cessent de transporter des objets, petits et grands, d'un lieu à un autre: les provisions du supermarché à la maison, les enfants, des sacs, des livres à l'école ou au travail, des outils au chantier... À cet effet, ils utilisent toutes sortes de contenants qu'ils détournent de leur fonction première.

Le persone diventano sempre più mobili; ciò significa anche che trasportano incessantemente avanti e indietro oggetti grandi e piccoli: cibo dal supermercato a casa, bambini, borse, libri a scuola o al lavoro, utensili al cantiere... Per fare ciò utilizzano ed inventano numerosi contenitori che, originariamente, servivano ad altri scopi.

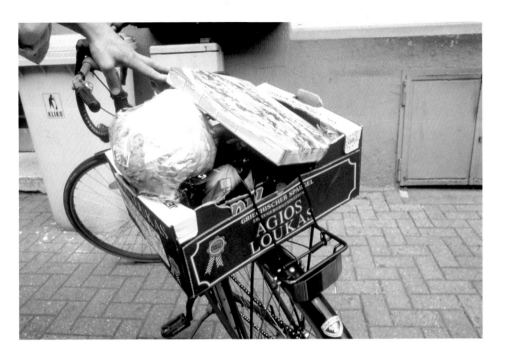

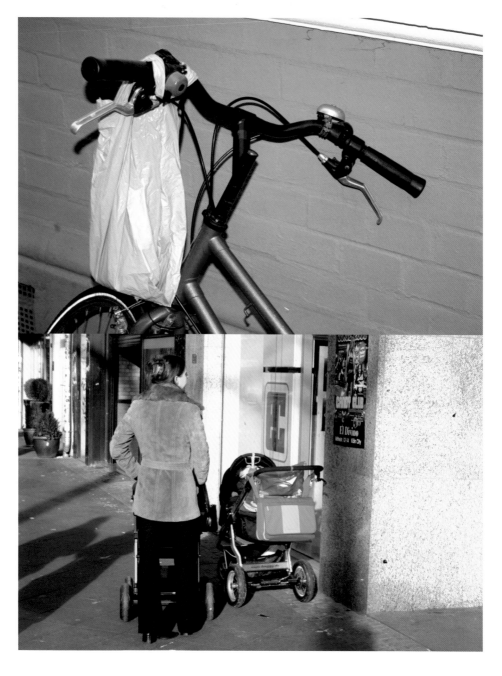

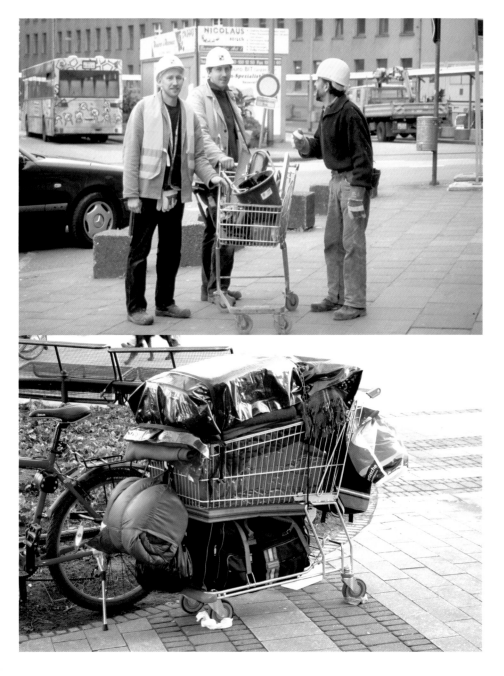

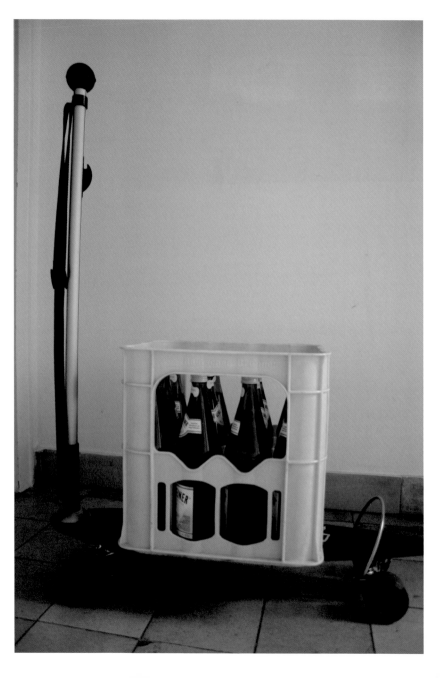

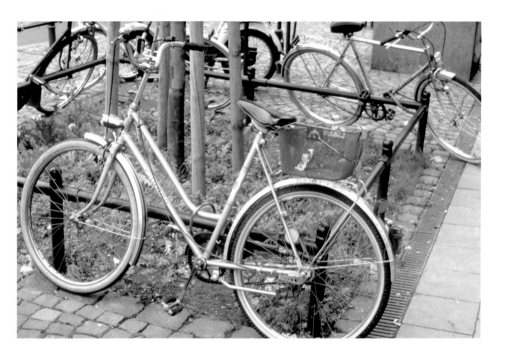

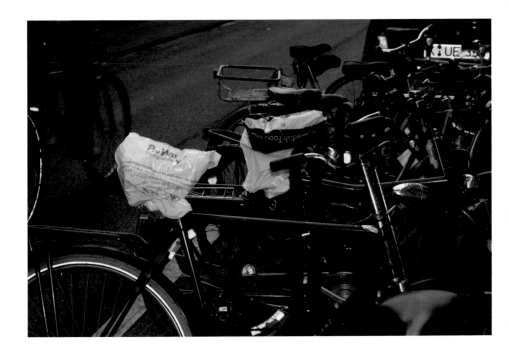

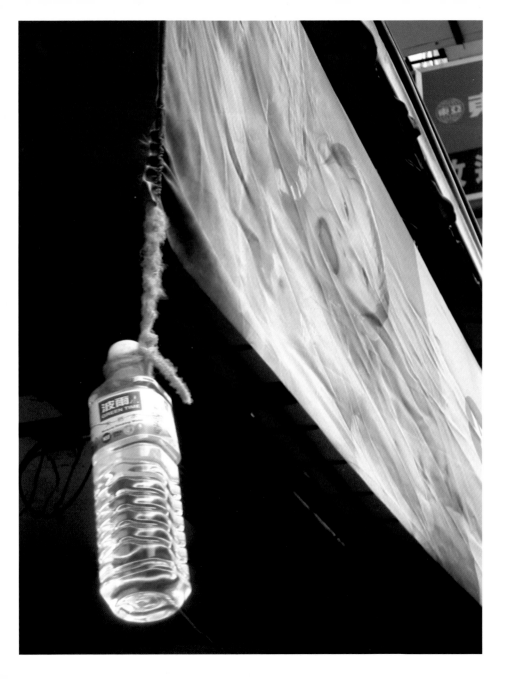

Impervious to wind and weather: rapid and simple fastening or stabilization.

Gefeit gegen Wind und Wetter: schnelles und einfaches Befestigen oder Stabilisieren.

Agitado por el viento y la intemperie: un modo más rápido de sujetar o estabilizar.

À l'abri du vent et des intempéries: fixation ou stabilisation rapide et simple

Immune contro il vento e il maltempo: fissaggio o stabilizzazione veloce e semplice.

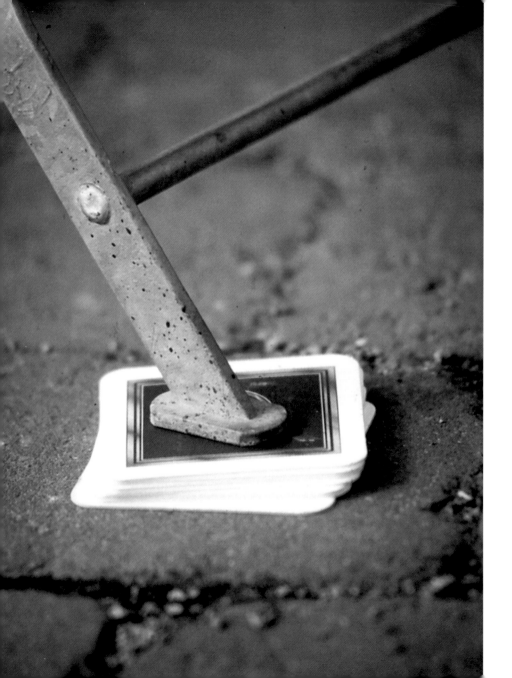

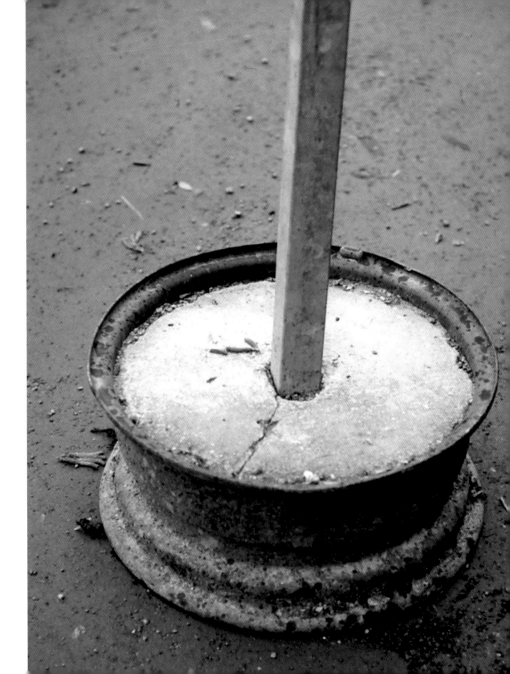

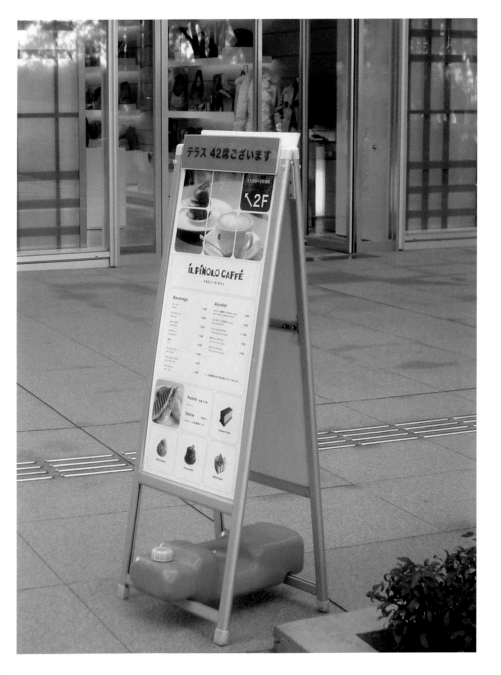

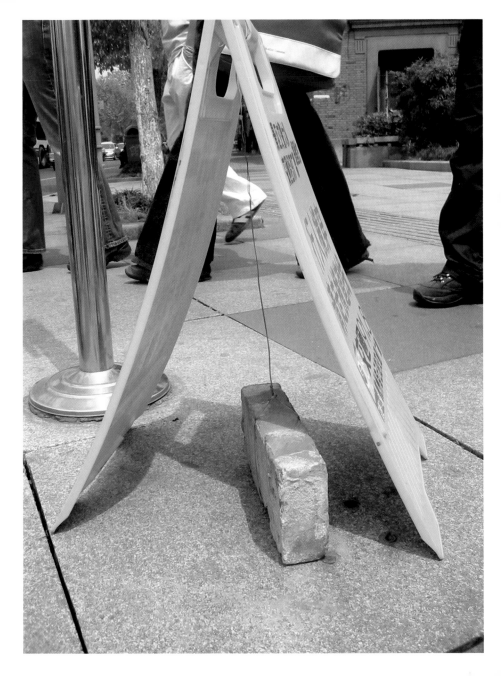

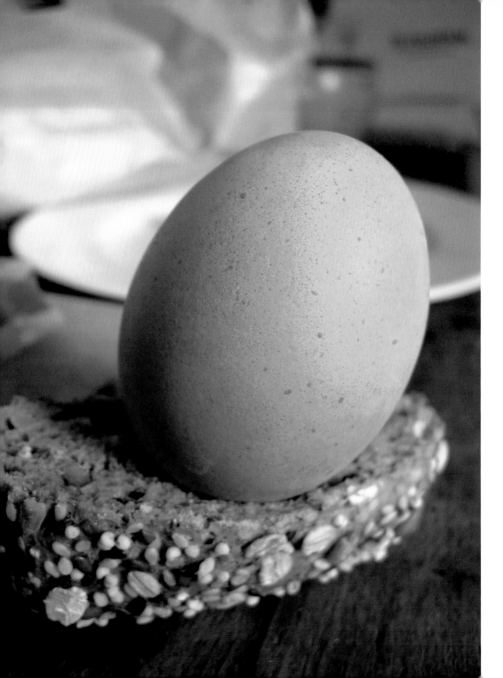

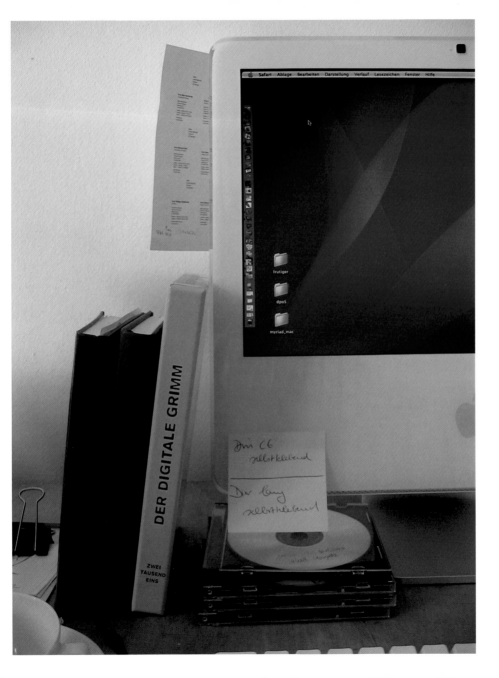

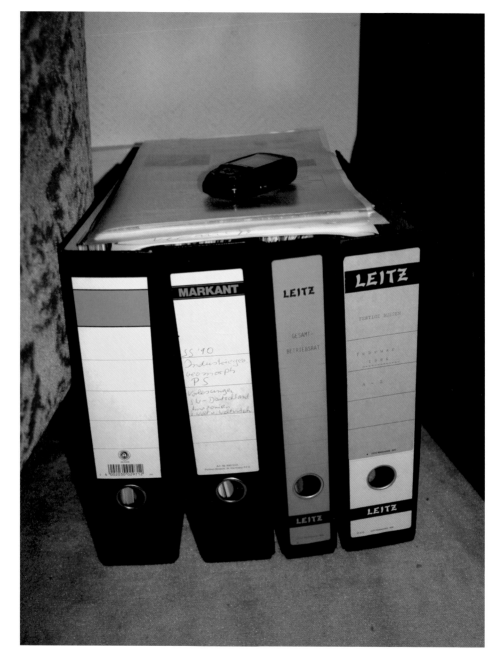

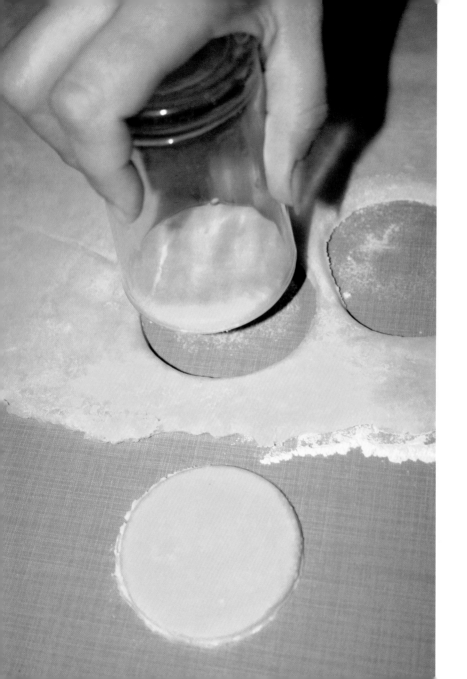

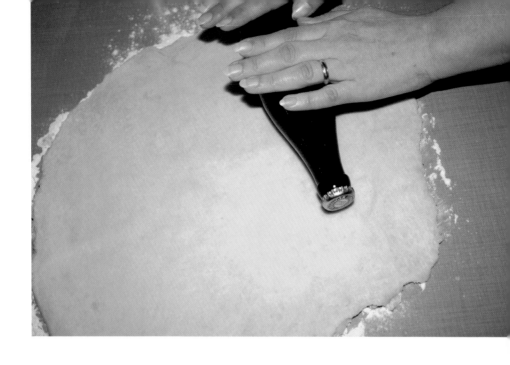

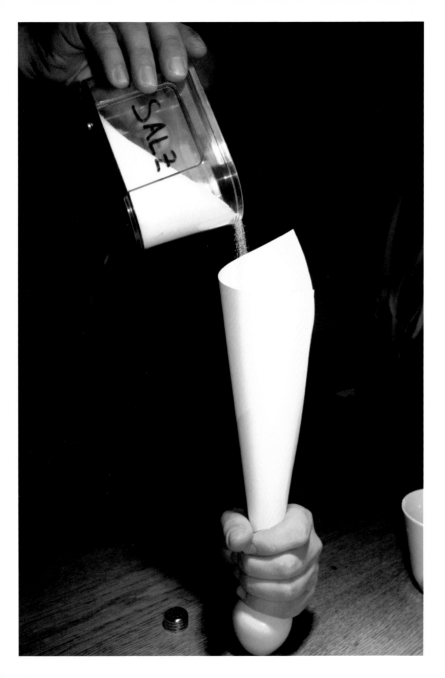

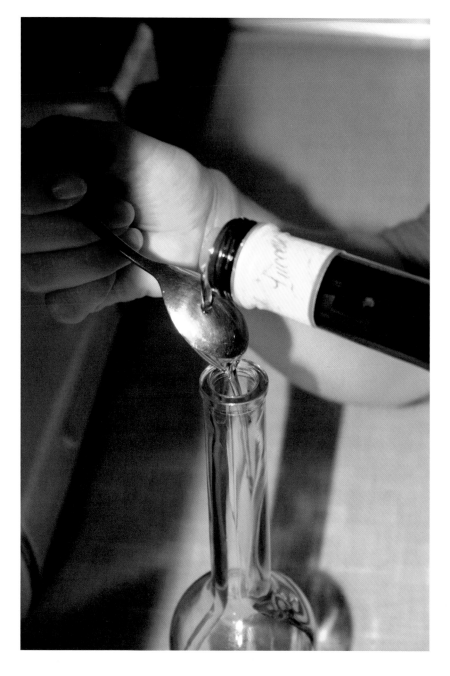

Sharpening knives with stones on the Taiwanese coast.

Messerschärfen mit Steinen an der taiwanesischen Küste.

Afilado de cuchillos con una piedra en la costa de Taiwán.

Affûtage de couteaux à la pierre sur le littoral taïwanais.

Affilatura con pietre sulla costa taiwanese.

Chopsticks for children invented by a Japanese cook working in Germany.

Essstäbchen für Kinder, die ein in Deutschland arbeitender japanischer Koch erfand.

Palillos para niños inventados por un cocinero japonés que trabaja en Alemania.

Brochettes pour enfants, mitonnées par un cuisinier japonais travaillant en Allemagne.

Bastoncini per bambini, inventati da un cuoco giapponese che lavora in Germania.

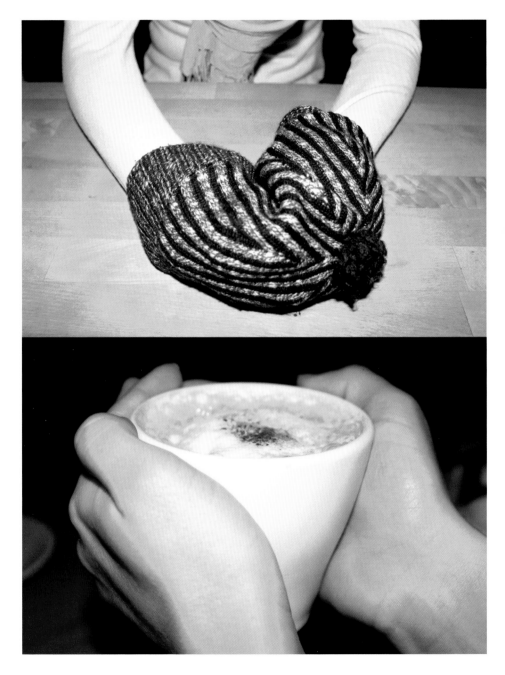

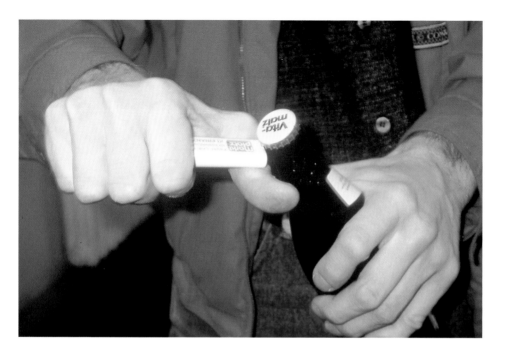

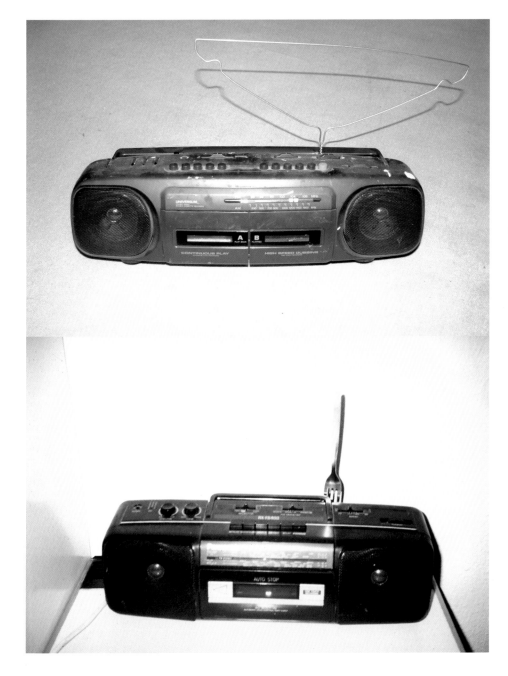

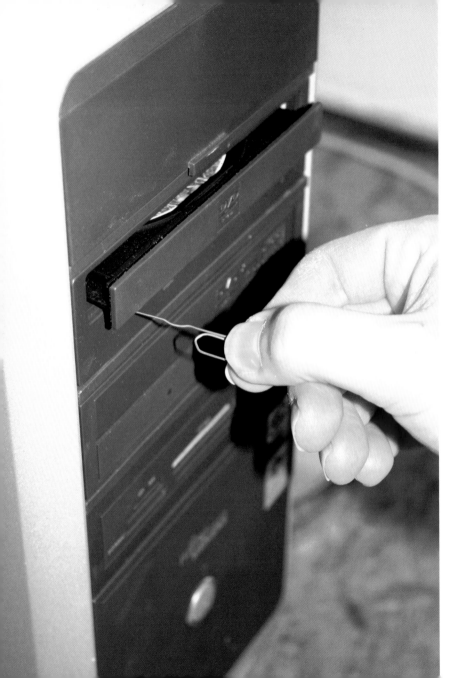

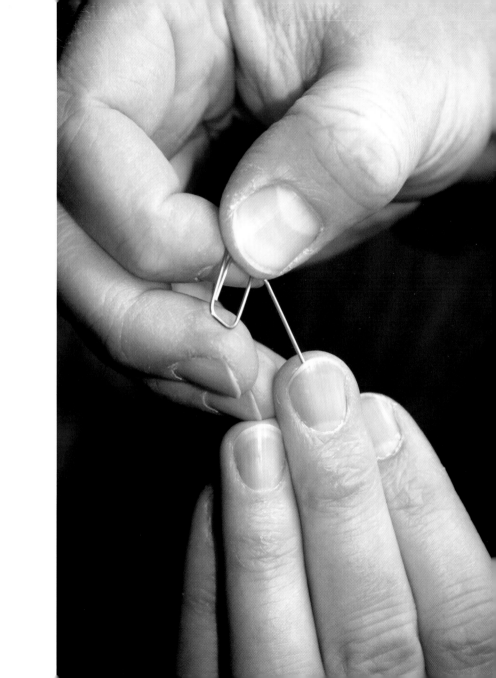

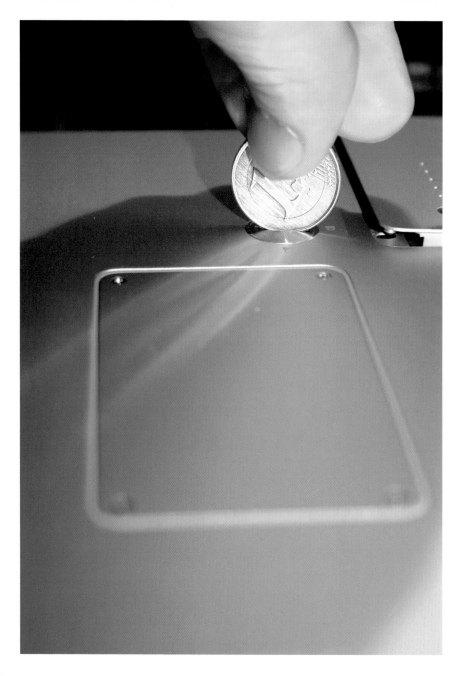

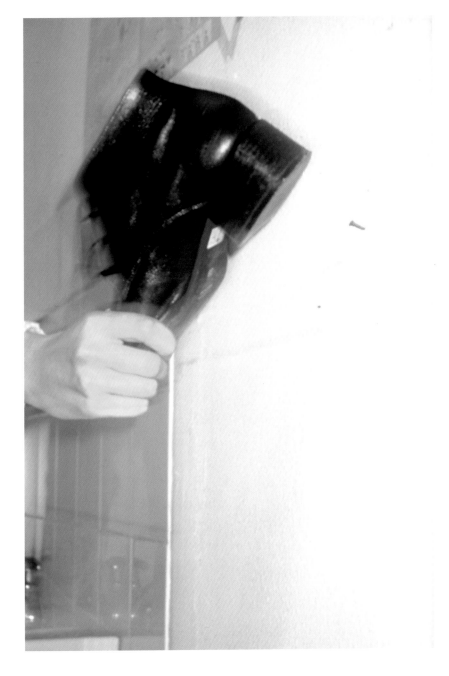

Celebrating crowds with upturned umbrellas catch sweets thrown from carnival floats during the Cologne carnival.

Im Kölner Straßen-Karneval werden Süßigkeiten von den Karnevalswagen geworfen, die die feiernden Menschen mit umgekehrt geöffneten Regenschirmen auffangen.

En el carnaval de Colonia se lanzan golosinas desde las carrozas, que el público jubiloso recoge con paraguas abiertos e invertidos.

Pendant le carnaval de Cologne, les fêtards ouvrent leurs parapluies à l'envers pour recueillir les friandises jetées du haut des chars.

Durante il carnevale di Colonia, per le strade vengono lanciati dai carri dolcetti che vengono raccolti dalle persone in festa con ombrelli aperti e girati al contrario.

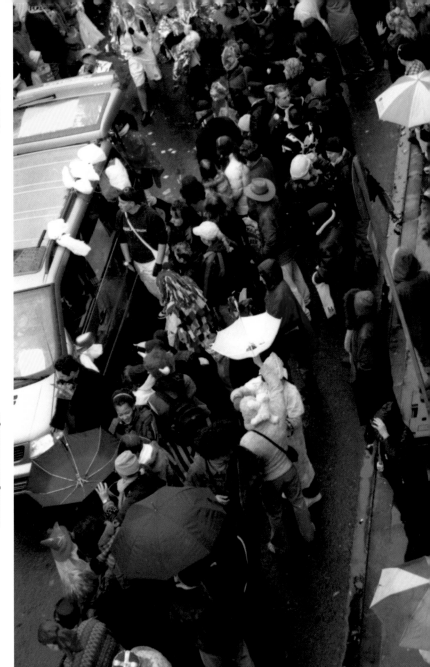

Some Christian influenced countries celebrate the holy day of St Nicholas – among other things the patron saint of children – on 6th December. On the preceding evening children put a (Nicholas) boot in front of their door to find it filled with sweets and small presents the next morning.

In einigen christlich geprägten Ländern gibt es zum 6. Dezember – dem Tag des heiligen Nikolaus, der unter anderem Patron der Kinder ist – für Kinder Süßigkeiten und kleine Geschenke im (Nikolaus) Stiefel, sofern dieser in der Nacht vor die Tür gestellt wurde.

En algunos países cristianos, el 6 de diciembre –día de San Nicolás, quien además es el santo patrón de los niños – los chiquillos reciben golosinas y pequeños regalos en una bota (de Nicolás) que se coloca esa noche ante la puerta.

Dans certains pays chrétiens, le 6 décembre, fête de saint Nicolas – patron des enfants entre autres – les petits découvrent des friandises et de petits cadeaux dans la botte (de saint Nicolas), s'ils ont pris soin, la veille, de la placer devant leur porte.

In alcuni paesi di religione cristiana, il 6 dicembre – il giorno di San Nicola che, tra l'altro, è anche il patrono dei bambini – i più piccoli ricevono dolcetti e regalini nello stivale, purché questo venga messo, durante la notte, davanti alla porta.

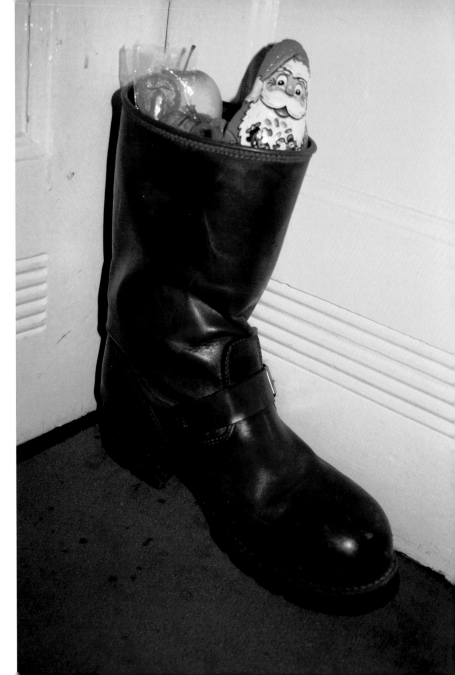

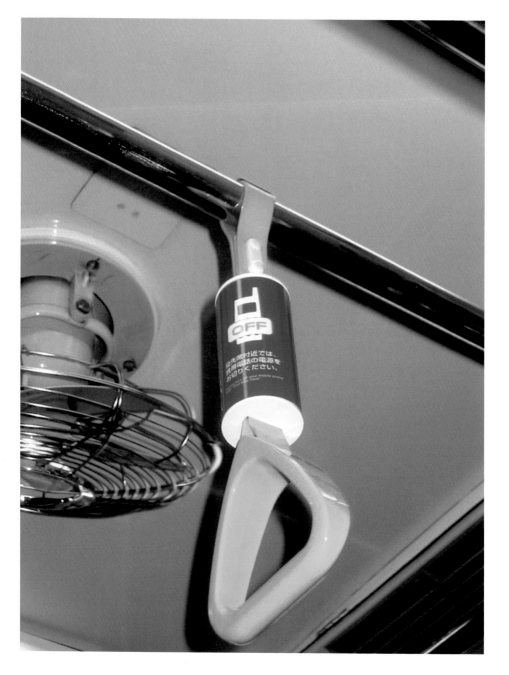

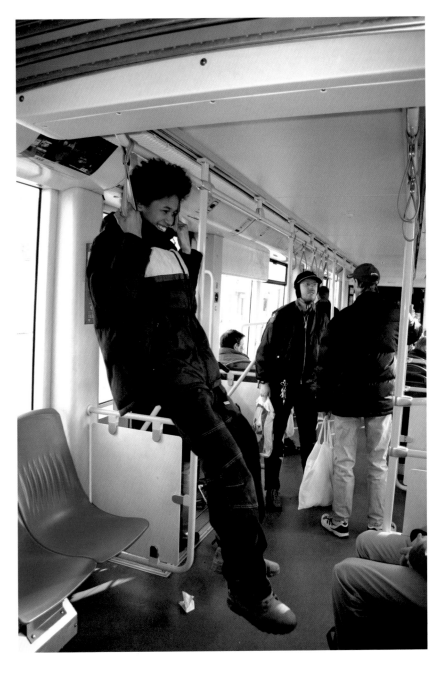

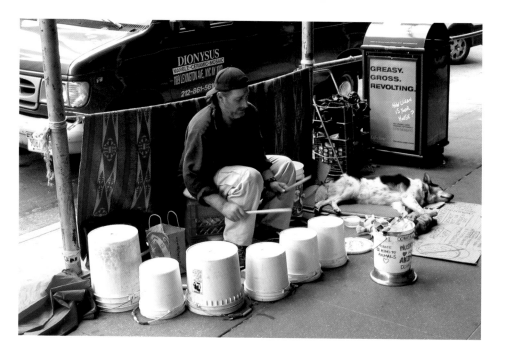

When everything becomes music and every object turns into an instrument.

Wenn alles zu Musik und jeder Gegenstand zum Instrument wird.

Cuando todo se convierte en música y cada objeto en un instrumento.

Quand tout devient musique et chaque objet un instrument.

Quando tutto viene trasformato in musica e ciascun oggetto in strumento.

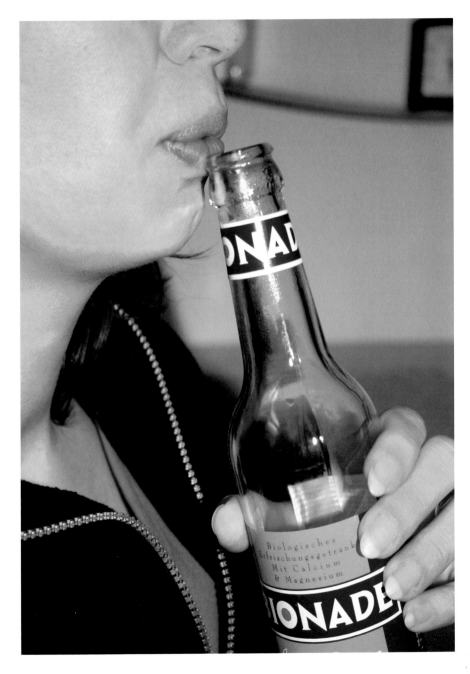

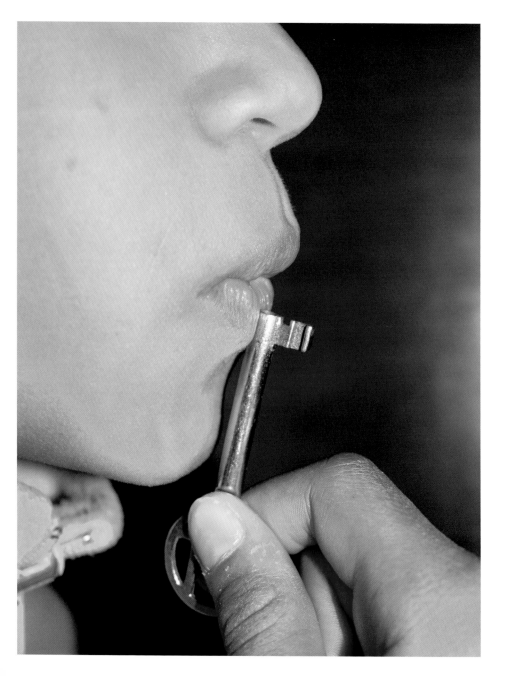

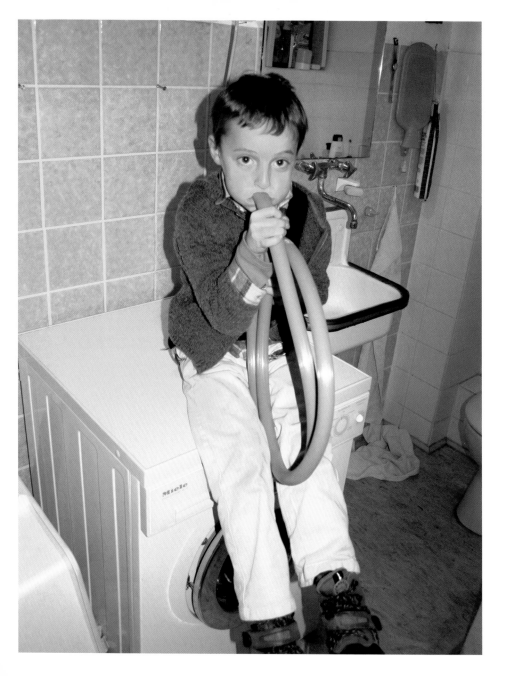

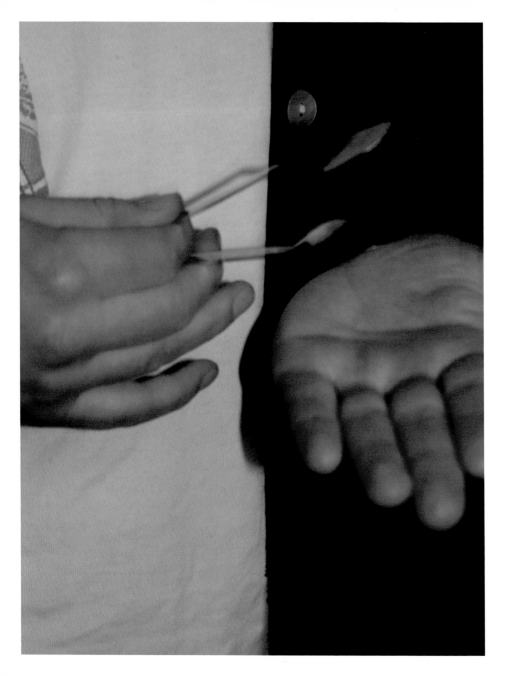

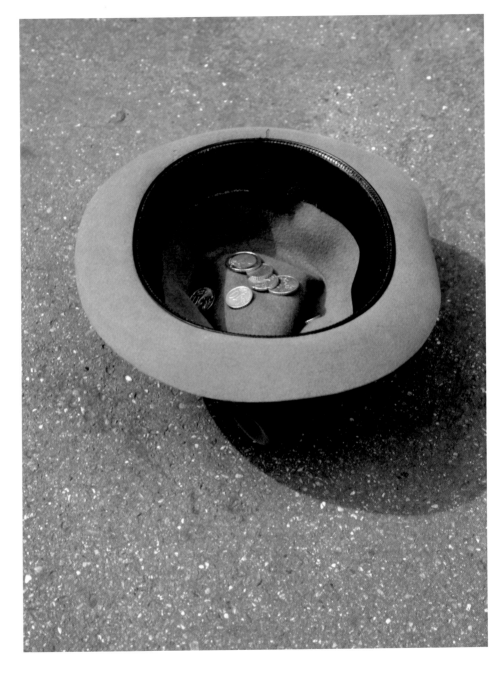

What in some cases began as an ordinary case of NID has increased in cultural value and ended up as a professionalised artistic or musical style: outside walls serve either as canvas or for informative purposes and prove ideal for graffiti or street art. Everybody knows how to fold a piece of paper and turn it into a plane; now there are books on the market with complicated folding instructions. And "deejaying" probably came about in the 1970s at "Urban Dance Parties" in the New York Bronx when disc jockeys started using their record players as instruments.

In einigen Fällen wurde das, was einst irgendwo ganz normal als NID begann, kulturell aufgewertet und so als künstlerischer oder musikalischer Stil professionalisiert: Hauswände als Malgrund oder für informative Zwecke mauserten sich zu Graffiti oder street art. Geschickt gefaltetes Papier flog schon immer gut, später erschienen dann Bücher mit diffizilen Faltanleitungen. Und das „Deejaying" (HipHop-DJs) entstand wahrscheinlich in den 1970er Jahren auf den „Urban Dance Parties" im New Yorker Stadtteil Bronx, als die Plattenaufleger den Plattenspieler als Instrument begriffen.

En algunos casos, lo que comenzó alguna vez, en algún sitio, como NID completamente normal, se ha revalorizado culturalmente y se ha profesionalizado artística o musicalmente: las facha-das utilizadas como lienzo o con fines informativos se han revelado como graffiti o street art. El papel hábilmente doblado siempre voló bien, pero más tarde aparecieron libros con compli-cadas instrucciones de doblado. Y el "deejaying" (DJs de HipHop) surgió probablemente en la década de 1970 en las "urban dance partys" del barrio neoyorquino de Bronx, cuando los disc jockeys utilizaban los platos giradiscos como instrumento.

Dans certains cas, un NID tout à fait anodin à ses débuts a bénéficié d'une réévaluation cultu-relle et, devenu style artistique ou musical, s'est vu professionnalisé: les murs, devenus toiles de fond ou supports d'information, se couvrent de graffiti ou se métamorphosent en street art. Les avions en papier ont toujours bien volé avant que n'apparaissent des livres expliquant des pliages plus élaborés. Et le «Deejaying» (DJs de HipHop) a sans doute vu le jour dans les années 1970 lors des «Urban Dance Parties» du Bronx, à New York, lorsque les animateurs ont découvert l'instrument qui sommeillait dans le tourne-disque.

In alcuni casi quello che un tempo, e in qualche luogo, è iniziato del tutto normalmente come NID, è stato culturalmente rivalutato e reso ufficiale come stile artistico o musicale: i muri delle case utilizzati come superfici per dipingere o a scopi informativi, si sono trasformati in graffiti o nella cosiddetta street art. La carta abilmente ripiegata ha sempre volato bene, ma più tardi sono apparsi libri con difficili istruzioni per effettuare queste pieghe. La figura del deejay (Hip Hop-DJs) è nata probabilmente negli anni '70, dagli „Urban Dance Parties" nel quartiere Bronx di New York, quando la persona addetta a cambiare i dischi ha iniziato a considerare il giradischi uno strumento.

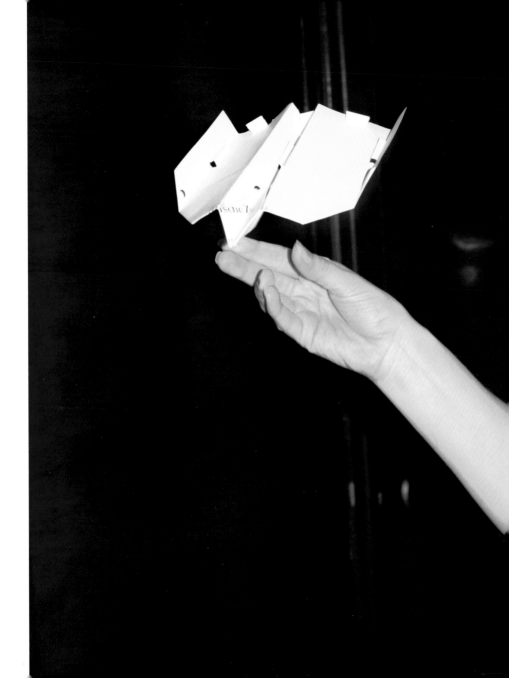

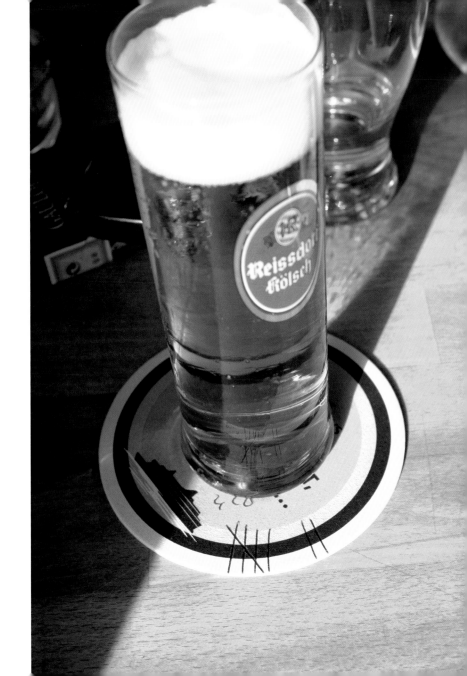

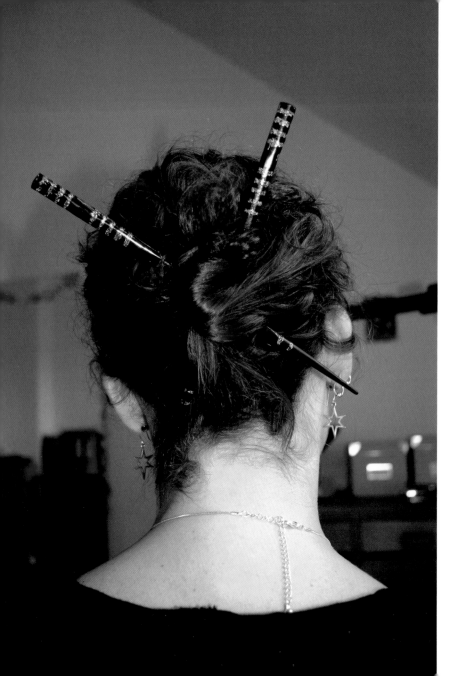

As seen in film and on television: even practical everyday objects serve as instruments of crime. (For ethical reasons, the innumerable NID instruments of murder and suicide are neither mentioned nor shown here.)

Bekannt aus Film und Fernsehen: Noch die simpelste kriminelle Energie bedient sich praktischer Alltagsdinge zur Verbrechensausführung. (Aus ethischen Gründen bleiben hier die unzähligen NID- Mord- und Selbstmordwaffen unerwähnt und ungezeigt.)

Sabido por el cine y la televisión: La más simple energía criminal se sirve de objetos prácticos de uso cotidiano para la ejecución de delitos. (Por razones éticas no se mencionan ni se muestran aquí las incontables armas NID utilizadas en asesinatos y suicidios).

Images classiques du cinéma et de la télévision: l'énergie criminelle la plus primitive se sert d'objets usuels pour parvenir à ses fins. (Pour des raisons d'éthique, les innombrables armes utilisées tant pour des meurtres que pour des suicides ne sont ici ni mentionnées ni montrées.)

Conosciuto dai film e dalla televisione: la più comune energia criminale si serve di oggetti pratici della vita quotidiana per compiere delitti (per motivi etici, le innumerevoli armi per delitti e suicidi NID non vengono citate e illustrate in questa sede).

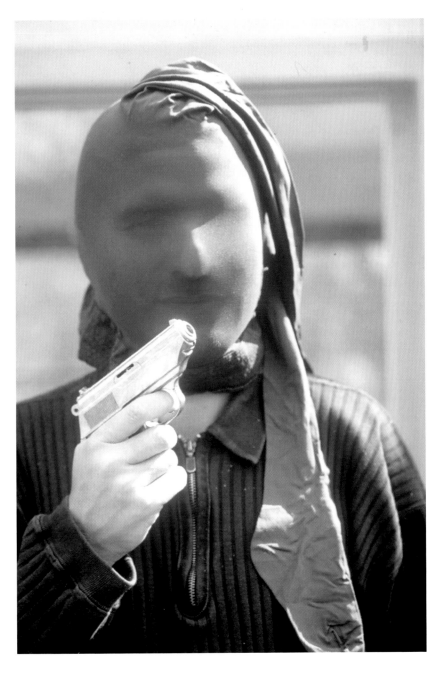

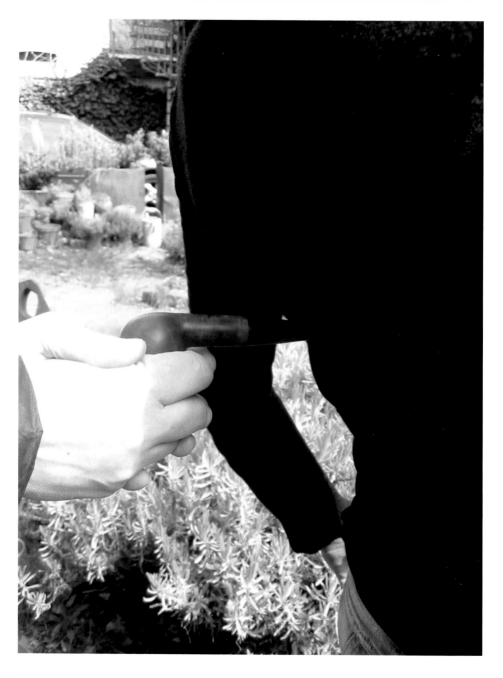

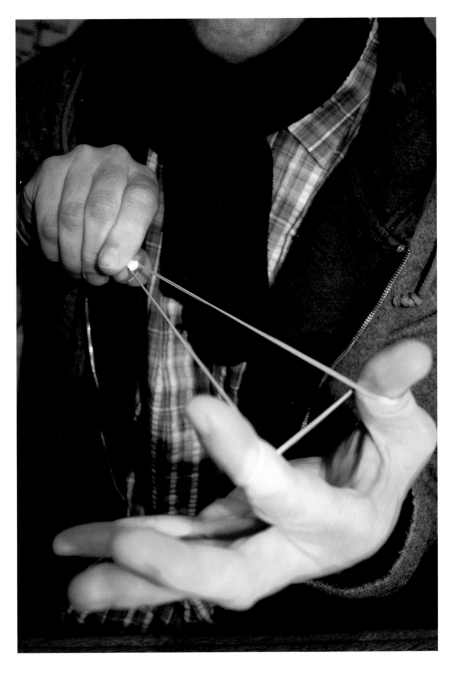

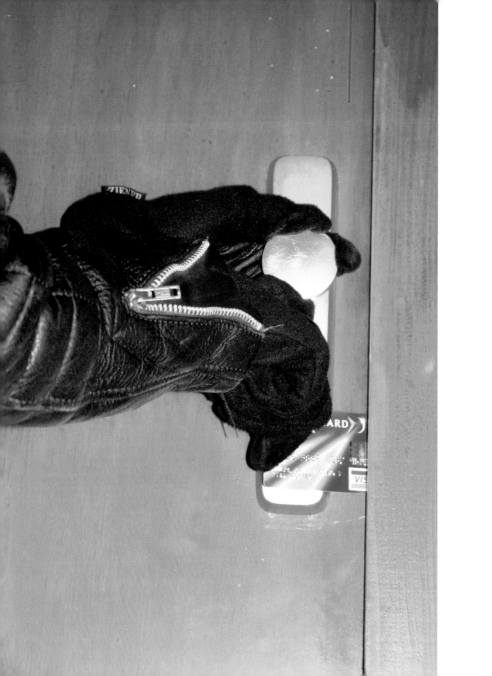

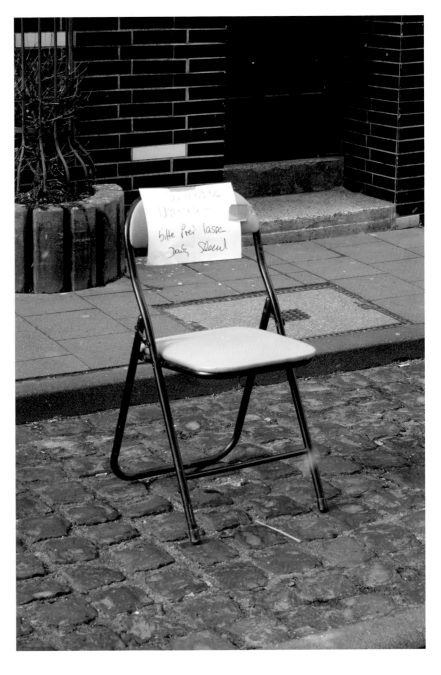

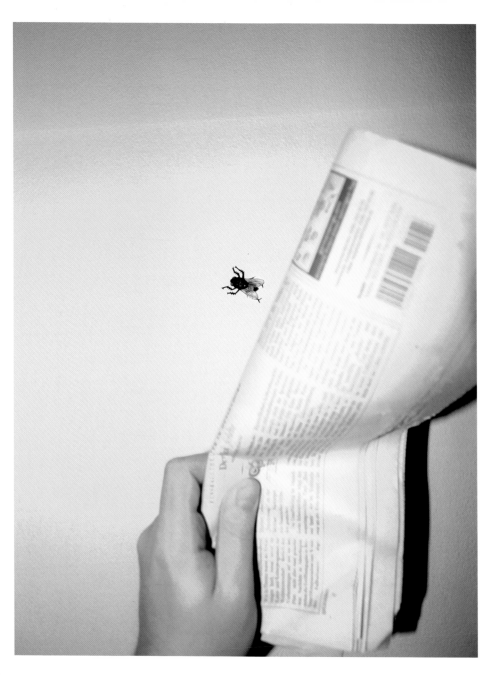

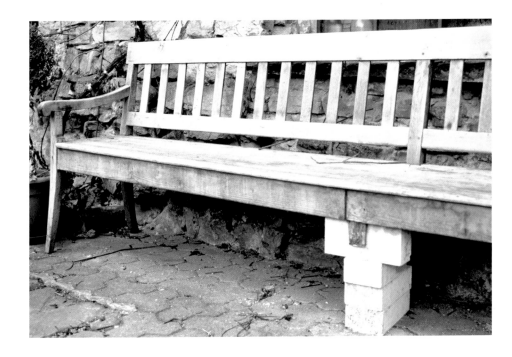

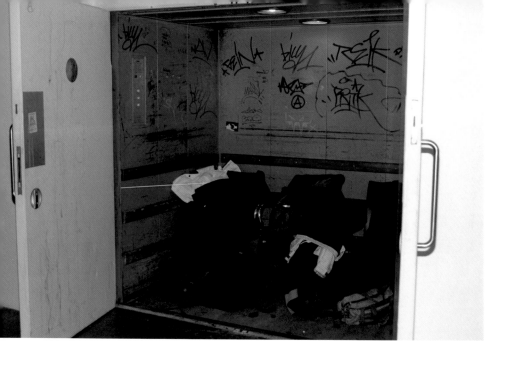

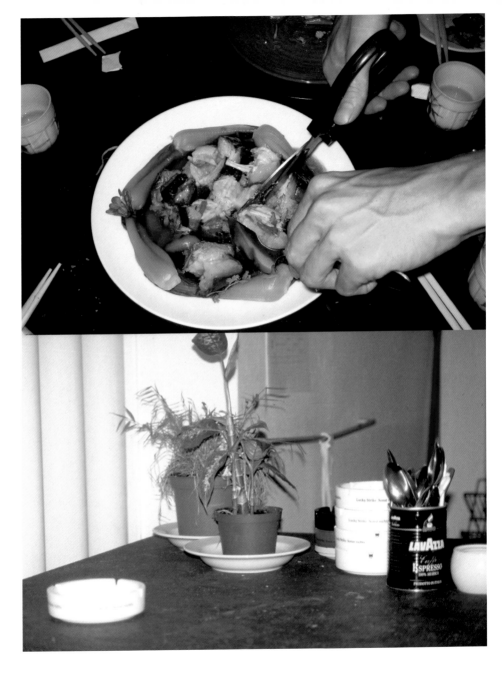

NID PRINCIPLES

1. Reversible conversion: an object is temporarily or permanently used in a new context, whereby, however, neither original state nor function are lost (jam jar as penholder).
2. Irreversible conversion: the new application either leaves permanent marks (bottle as candle holder) or the original object is permanently altered (holes in screw-on lid to be used as sugar sprinkler).
3. Almost all conversions imply multi-functionality.
4. Location change: objects are either removed from their intended surroundings (roof tiles as shelf posts) or, alternatively, a location is used for a new function (parties under bridges).

NID MOTIVES

1. Making a virtue out of necessity: temporary solutions, stopgaps, improvisations (saucer as ashtray).
2. For a particular application for which there is no product on the market (beer mat under a table leg to stabilize the table).
3. Cheap alternatives to new products (bed frame made of pallets).
4. Recycling waste material or used products for ecological or financial reasons (fork or coat hanger as radio aerial) – or just for fun (empty can as football).
5. Reduction in effort or movement (saucer as ashtray).
6. Optimization of function (chair as coat stand and ladder).

NID-PRINZIPIEN

1. Reversible Umnutzung: Ein Ding wird temporär oder dauerhaft in einem neuen Kontext genutzt, wobei aber der ursprüngliche Zustand und die ursprüngliche Funktion nicht zerstört werden (Senfglas als Stiftbehälter).
2. Irreversible Umnutzung: Entweder hinterlässt der neue Gebrauch bleibende Spuren (Flasche als Kerzenständer), oder das Objekt muss für die neue Anwendung dauerhaft verändert werden (Schraubglas mit durchlöchertem Deckel als Zuckerstreuer).
3. Fast alle Umnutzungen implizieren Multifunktionalität.
4. Ortsveränderung: Dinge werden aus ihrem ursprünglichen Einsatzort herausgelöst (Ziegelsteine als Regalständer) oder umgekehrt wird ein Ort zu einem neuen Zweck umfunktioniert (Parties unter Brücken).

NID-MOTIVE

1. Aus der Not eine Tugend machen: Notlösung, Provisorium, Improvisation (Untertasse als Aschenbecher).
2. Für den speziellen Zweck wird nichts Passendes auf dem Markt angeboten (Bierdeckel unter Tischbein, um den Tisch zu stabilisieren).
3. Kostengünstige Alternativen zu neu gekauften Produkten (Bettgestell aus Europaletten).
4. Weiterverwendung von Wegwerf- oder eigentlich schon verbrauchten Produkten aus ökologischen oder Kostengründen (Gabel oder Kleiderbügel als Radioantenne) – oder einfach aus Spaß (leere Dose als Fußball).
5. Reduktion von Aufwand oder Wegersparnis aus Bequemlichkeit (Füße auf Schreibtisch)
6. Optimierung der Funktion (Stuhl als Garderobe und Leiter).

PRINCIPIOS NID

1. Cambio de uso reversible: una cosa se utiliza temporal o permanentemente en un nuevo contexto, sin destruir por ello su estado o función original (frasco de mostaza como vaso para lápices).
2. Cambio de uso irreversible: La nueva utilización deja huellas duraderas (botella convertida en candelabro) o el objeto ha de ser transformado permanentemente para su nueva utilización (frasco con tape de rosca que se perfora para utilizarlo como azucarero).
3. Casi todos los cambios de uso implican multifuncionalidad.
4. Cambio de emplazamiento: las cosas son retiradas de su lugar de uso original (ladrillos para sujetar estanterías) o al revés, un lugar pasa a tener nuevas funciones (fiestas debajo de puentes).

MOTIVOS NID

1. Hacer de la necesidad una virtud: soluciones de emergencia, arreglos provisionales, improvisaciones (platillo como cenicero).
2. En el mercado no se encuentra nada que se ajuste a un fin determinado (posavasos de cartón bajo la pata de la mesa para estabilizarla).
3. Alternativas económicas a productos que se compran nuevos (somier hecho de europalets de madera)
4. Reutilización de objetos de deshecho o que ya han sido utilizados, por motivos ecológicos o económicos (tenedor o percha como antena de radio) o simplemente por diversión (lata vacía como pelota de fútbol).
5. Reducción de medios o de trayectos por comodidad (platillo como cenicero).
6. Optimización de la función (silla como guardarropa o escalerilla).

LES PRINCIPES DU NID

1. Réversibilité: un objet est utilisé dans un nouveau contexte, de façon temporaire ou durable, mais sans destruction de son état et de sa fonction d'origine (le pot de moutarde comme porte-crayons).

2. Non-réversibilité: le nouvel usage laisse soit des traces persistantes (bouteille-bougeoir), soit une modification permanente (couvercle percé du pot de moutarde qui devient sucrier).

3. Presque tous les nouveaux emplois aboutissent à multiplier les fonctions.

4. Changement de lieu: les objets sont détachés de leur site d'origine (briques soutenant des étagères) ou, au contraire, le lieu reçoit une nouvelle vocation (fête sous un pont).

LES MOTIVATIONS DU NID

1. Faire preuve de débrouillardise: solution de secours, provisoire, improvisation (soucoupe tenant lieu de cendrier).

2. Le commerce n'offre rien qui convienne à la fonction recherchée (dessous-de-verre sous un pied de table, pour la stabiliser).

3. Alternatives bon marché à l'achat de produits neufs (sommier constitué d'Europalettes).

4. Pour des raisons écologiques ou financières, recyclage d'objets jetables ou usagés (fourchette ou cintre comme antenne de radio), – ou simplement pour s'amuser (boîte de conserve vide comme ballon).

5. Souci d'économie d'argent ou d'effort (soucoupe servant de cendrier).

6. Optimisation de la fonction (chaise comme penderie ou comme escabeau).

PRINCIPI DEL NID

1. Trasformazione reversibile: un oggetto viene utilizzato, temporaneamente o permanentemente, in un nuovo contesto, senza tuttavia distruggere lo status e la funzione originaria (il vasetto di senape diventa un portapenne).

2. Trasformazione irreversibile: o il nuovo utilizzo lascia tracce permanenti (una bottiglia impiegata come candeliere), oppure questo deve essere modificato permanentemente per il nuovo scopo (un vasetto con un coperchio bucherellato diventa uno spargizucchero).

3. Quasi tutte le trasformazioni implicano una multifunzionalità.

4. Modifica del luogo: gli oggetti vengono rimossi dal loro luogo d'impiego originario (i mattoni diventano colonna portante di uno scaffale) o, al contrario, un luogo viene adattato ad un nuovo scopo (feste sotto i ponti).

MOTIVI DEL NID

1. Fare di necessità virtù: soluzione provvisoria, di ripiego, improvvisazione (piattino come posacenere).

2. Per lo scopo particolare non viene offerto nulla di adeguato sul mercato (sottobicchiere utilizzato per equilibrare il tavolo).

3. Alternative economiche a nuovi prodotti venduti (struttura del letto realizzata con bancali).

4. Riutilizzo di prodotti a perdere, o già logori, per motivi ecologici o di costo (una forchetta o una gruccia come antenna radio – o semplicemente per divertimento (una lattina vuota come pallone da calcio).

5. Riduzione dello spreco o risparmio per comodità (piattino come posacenere).

6. Ottimizzazione della funzione (sedia come guardaroba e scala).

Many more examples of Non Intentional Design will almost certainly have occurred to you whilst reading and looking at this book. Perhaps you would like to send us your NID photographs on a CD (resolution: at least 300 dpi) to the following address:

Michael Erlhoff, KISD, Ubierring 40, D-50678 Köln.

By doing so, you are giving consent for your photos to be published free of charge under your name. Given enough material, there may well follow a second NID volume.

Bestimmt sind Ihnen beim Lesen und Betrachten dieses Buches selbst noch viele weitere Beispiele für Non Intentional Design eingefallen. Wenn Sie mögen, senden Sie uns einfach Ihre NID-Fotos auf einer CD (Auflösung: mindestens 300 dpi) an folgende Adresse:

Michael Erlhoff, KISD, Ubierring 40, D-50678 Köln.

Sie erklären sich damit zugleich einverstanden, dass Ihre Fotos unter Nennung Ihres Namens gegebenenfalls honorarfrei veröffentlicht werden. Denn vielleicht ergibt das ja einen zweiten NID-Band.

Seguro que mientras leía y contemplaba este libro se le han ocurrido a usted mismo muchos otros ejemplos de Non Intencional Design. Si lo desea, puede mandar sus fotos NID en un CD (resolución: mínimo 300 dpi) a la siguiente dirección:

Michael Erlhoff, KISD, Ubierring 40, D-50678 Köln.

También ha de dar su consentimiento para que sus fotos se publiquen mencionando su nombre y sin ningún tiempo de gratificación. Pues tal vez haya un segundo volumen NID.

En lisant et feuilletant ce livre, vous avez sans doute pensé à bien d'autres exemples de Non Intentional Design. Si vous le souhaitez, envoyez-nous simplement vos photos de NID sur un CD (résolution : au moins 300 dpi) à l'adresse suivante:

Michael Erlhoff, KISD, Ubierring 40, D-50678 Köln.

Vous consentez ainsi à ce que vos photos soient publiées sous votre nom, éventuellement à titre gracieux, car il est possible qu'un autre tome sur le NID voie le jour.

Senz'altro durante la lettura e l'osservazione di questo libro vi saranno venuti in mente molti altri esempi di Non Intentional Design. Se lo desiderate, potete semplicemente inviarci le vostre foto-NID su CD-rom (definizione: almeno 300 dpi) al seguente indirizzo:

Michael Erlhoff, KISD, Ubierring 40, D-50678 Köln.

In questo modo, vi dichiarate d'accordo con l'eventuale pubblicazione, a titolo gratuito, delle vostre foto, con citazione del vostro nome. Chissà, magari potrebbe essere realizzato un secondo volume NID.

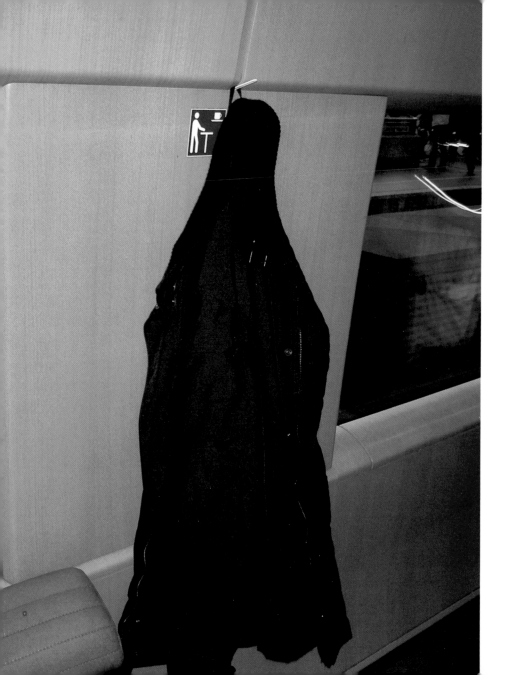

UTA BRANDES

professor for gender and design and qualitative design research at the Köln International School of Design, author, co-founder and co-owner of be design, co-organiser of the St. Moritz Design Summit, and chairwomen of the German Association for the Theory and Research in Design. She lives in Cologne (D).

MICHAEL ERLHOFF

founding dean of the Köln International School of Design, professor for design theory and history, author, co-founder of the St. Moritz Design Summit, former director of the German Design Council and former president of the Raymond Loewy Foundation International. He lives in Cologne.

© 2006 daab
cologne london new york

published and distributed worldwide by
daab gmbh
friesenstr. 50
d - 50670 köln

p +49 - 221 - 94 10 740
f +49 - 221 - 94 10 741

mail@daab-online.com
www.daab-online.com

publisher ralf daab
rdaab@daab-online.com

creative director feyyaz
mail@feyyaz.com

edited & written by uta brandes & michael erlhoff, www.be-design.info

design sebastian dörken, info@sbdsgn.de

project assistance dirk porten

english translation ingo wagener
translations and copy editing by durante & zoratti, cologne

photo credits uta brandes, michael erlhoff, feyyaz, irène kwong, julia moeck, dirk porten, peter steinmetz

special thanks to jenny preissler & timur sanda

printed in slovenia
mkt print d.d., slovenia
www.mkt-print.com

isbn-10 3-937718-93-1
isbn-13 978-3-937718-93-4